IMAGES
of America

INDIANA,
PENNSYLVANIA

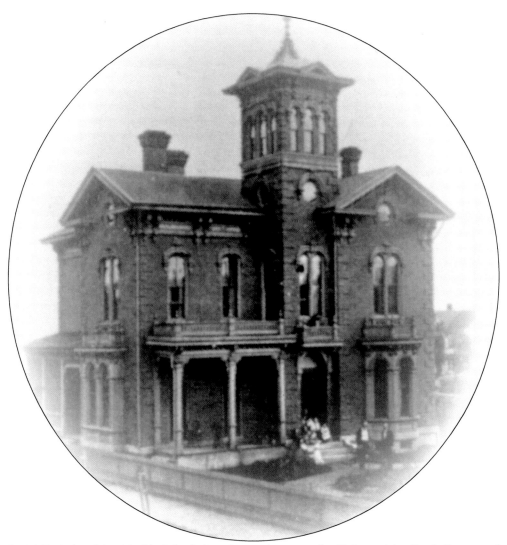

In 1869, Judge Silas M. Clark built his elegant home at the Y formed by Sixth Street and Wayne Avenue. This was the site of the Indiana Academy, which had burned down five years earlier. The $12,000 Victorian mansion was completed in 1870. It was later known as Memorial Hall and, in the 1990s, became the home of the Historical and Genealogical Society of Indiana County.

IMAGES
of America

INDIANA, PENNSYLVANIA

Karen Wood and Doug MacGregor

ARCADIA
PUBLISHING

Published by Arcadia Publishing
Charleston, South Carolina

Printed in the United States of America

Library of Congress Catalog Card Number: 2002105006

For all general information contact Arcadia Publishing at:
Telephone 843-853-2070
Fax 843-853-0044
E-mail sales@arcadiapublishing.com
For customer service and orders:
Toll-Free 1-888-313-2665

Visit us on the Internet at www.arcadiapublishing.com

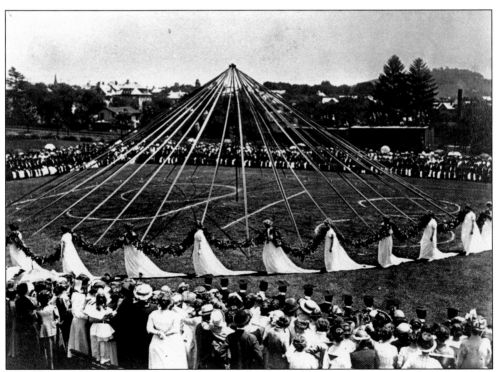

The Swingout was a tradition that began in the earliest days of the Indiana State Normal School. The pageant was part of the festivities surrounding Commencement Week. Swingout continued as a tradition until its popularity waned in the 1970s.

CONTENTS

ACKNOWLEDGMENTS

Creating this book has been a labor of love, but a labor just the same. We would like to extend our sincere thanks to those who made our work easier. Images of Indiana, its buildings, and people were graciously provided by the Historical and Genealogical Society of Indiana County. Photographs of Indiana University of Pennsylvania were made available through the generosity of Philip Zorich, director of the Special Collections and University Archives Department at Stapleton Library, Indiana University of Pennsylvania. Gathering the images was only the first half of the work, and we are deeply indebted to Clarence D. Stephenson and his remarkably informative and well-researched histories of Indiana County for their invaluable assistance in documenting these images. We would like to thank our friends and families—specifically Bill Wood, Ruth MacGregor, Sue and Bill Forbes, Coleen Chambers, and Barb Waltemire—for their helpful suggestions, for sharing their own memories of Indiana, and for their patience while we were immersed in this project. Last but not least, we are grateful to the kind individuals who have donated their photographs to historical collections and archives so that a book like this was made possible.

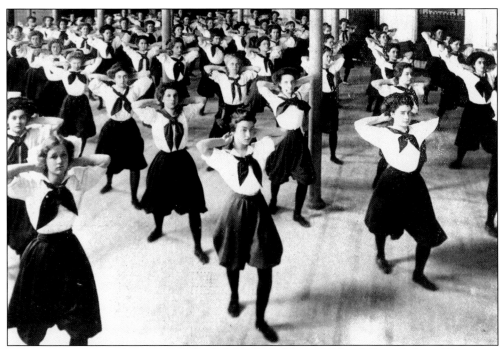

Many young women who attended the Indiana State Normal School (later Indiana University of Pennsylvania) in the early 20th century had grown up in rural areas where exercise was a necessary part of their everyday routines. Stretching and calisthenics classes replaced their previous daily chores and provided a welcome break from academic pursuits.

INTRODUCTION

The town of Indiana, Pennsylvania, lies at the crossroads of two old Native American trails, the Catawba Trail and the Kittanning Path, which were major east-west and north-south travel and trading routes in the days before European settlers made their way to the area. In the 200 years since Indiana County was organized and the county seat was settled, Indiana has grown economically, socially, and culturally with the development of a community, an industrial base, and an enduring educational presence with Indiana University of Pennsylvania.

On March 30, 1803, parts of Westmoreland and Lycoming Counties were combined to form Indiana County as part of Pennsylvania House Bill No. 44. James Parr, William Jack, and John Pomroy, all from Westmoreland County, were granted the rights to control the grant or sale of lands in the new county. Several months later, discussions began concerning the location of the county seat. Thomas Gilpin wanted to create Gilpinsbourg northeast of present-day Indiana. George Clymer, a signer of the Declaration of Independence and the U.S. Constitution, preferred that his piece of land called the Glade Tract be used. The county was surveyed, and the commissioners decided on April 11, 1804, to locate the new town between Fergus Moorhead's house (just west of town on present-day Route 422) and George Trimble's place (on north Fourth Street just past the borough line) in the geographic center of the county on Clymer's land. The commissioners were dismissed, and county trustees were appointed in their place. The trustees laid out 225 town lots and 92 out lots based on the survey of Thomas Allison, assisted by his son Andrew, James Hamilton, and James McLain.

Advertisements for the sale of lots in Indiana County were placed in newspapers across Pennsylvania, and sales began on December 10, 1805. On March 10, 1806, the Pennsylvania General Assembly passed an act allowing for the county's first elections, providing for the selection of two candidates for sheriff, two for coroner, and three county commissioners. Elections were to be held, as they are today, after the first Monday in November. That year, Thomas McCartney was elected the first high sheriff, Samuel Young was elected coroner, and commissioners were chosen to be William Clark, James Johnston, and Alexander McLain. Peter Sutton, an early county settler from Basking Ridge, New Jersey, had built a hotel and tavern at the corner of Philadelphia and Carpenter Avenues, and the county's first courts were held here, having been transferred from the jurisdiction of Westmoreland County. Early court cases concerned assault and battery, horse theft, and fornication. Other early court activities centered on petitions for naturalization, oaths of allegiance, and road construction. The town was granted an official post office in 1810.

On March 11, 1816, the borough of Indiana was incorporated by an act of the Pennsylvania General Assembly. By this time, Indiana had built its second jail, its first courthouse, and a row of offices west of the courthouse to house offices for the commissioners. The area also offered a general store (John Denniston's store, later the location of Steiner's Market), several taverns and hotels, several blacksmiths (Conrad Rice and son Philip), a wheelwright and chair-making shop (Sheriff McCartney's), a shoemaker, a clockmaker, a school, a cabinet shop, carpenters, brickmakers, tanneries, masons, tailors, and dozens of family cabins and homes. Early church services were held outdoors or in the jail, until the courthouse was completed. Blacksmith Conrad Rice turned over some of his land for a public cemetery, later the site of Memorial Park.

By 1843, the town had grown to have some 700 residents along with a variety of thriving businesses. Better roads were being constructed, and waterways were still an important mode

of travel throughout the county. New townships had been organized to make a total of 13: Armstrong, Black Lick, Brush Valley, Center, Conemaugh, Green, Mahoning, Montgomery, Rayne, Washington, Wheatfield, White, and Young.

As with many developing towns in the early 19th century, most of the first businesses were those that supported the growing population, such as taverns and hotels, flour mills, lumbermills, breweries, harness shops, blacksmiths, and general stores. By midcentury, Indiana had developed a number of promising industries, including the Indiana Foundry Company, the Indiana Bent-Rung Ladder Company, and the Strawboard Mill. The arrival of the railroad in the 1850s allowed these businesses to expand their operations to incorporate national and international transactions, thus taking advantage of a much broader market. The railroad also contributed to a growing sense of worldliness among Indiana's citizens as current fashions and new inventions appeared in town from the East Coast. The town was making the transition from being a rural village to becoming a more modern center of industrial and cultural activity.

In the hundred years following the arrival of the railroad, Indiana became the hub of a variety of countywide industries, including coal mining and the cultivation of Christmas trees. Large coal companies such as the Rochester & Pittsburgh Coal and Iron Company and the Clearfield Bituminous Coal Corporation built their headquarters in town to support their operations throughout the county and the region. Company towns were built to house and support the influx of eastern European immigrant miners around the county, but long hours, low pay, and the tyranny of the company store kept many of their residents from spending time and money in Indiana. Company owners had immense wealth at their disposal, and although many of them spent it primarily on their own needs (building extensive homes and living extravagantly), others contributed to their communities. Between 1890 and 1907, 1,614 miners were injured or killed in work-related accidents in Pennsylvania coal mines, including the February 11, 1916 tragedy at Ernest Mine, where 27 men lost their lives. Coal magnate Adrian Iselin helped to balance the scales by funding the new Indiana Hospital in 1914 when the town was unable to raise the required funds.

Manufacturing concerns including Robertshaw Controls, McCreary Tire & Rubber, and Dugan Glass also developed in the 20th century, bringing with them prosperity. Immigration, primarily from southern and eastern Europe was at an all-time high in the late 19th and early 20th centuries, and many of these newcomers found work in the factories, mines, and industries in Indiana and surrounding towns. Their presence brought cultural and social diversity to a town that was primarily Scotch-Irish in origin. In the years following World War II, however, manufacturing and heavy industry throughout western Pennsylvania began to decline as competition grew with international markets. In the later part of the century, many of these companies were forced to downsize or close, slowing Indiana's economic growth and mirroring the situation in many areas of the country after the war.

As heavy industry has taken an increasingly smaller role in Indiana's financial sphere, the role of education has continuously expanded throughout the town's history. Indiana's first school was opened by 1807, only two years after lots in town were first made available for purchase. Seven years later, in 1814, the Indiana Academy opened to provide education beyond the elementary school level for local residents. Public schools were built, remodeled, razed, and rebuilt as the number of children in the borough grew. Then, in 1875, the Indiana State Normal School was opened, providing local and regional residents an opportunity for advanced learning.

The institution provided more than an education for many young women in the region. For them, the certificate or diploma they earned could open the door to a more independent life in a time when women moved almost directly from the control of their fathers at home to that of their husbands after marriage. In addition to standard coursework, female students learned to build and carve bookcases, and other skills less traditional for women of the time. Social and recreational activities for students were also often focused around supporting the primarily female population of the normal school. Swingout celebrations and costume parties were part of the commencement-time festivities, as was the George Washington Ball for senior classes, all

occasions to dress up in their Sunday best or some interesting or unusual costume. The school also provided field trips for art classes, hayrides, and Halloween parties.

The Indiana State Normal School has remained an integral part of the Indiana community, and its presence and growth has enabled the town to flourish with a strong tradition of sporting, informative, and cultural events that draw national and international figures. In the days when it was the normal school, William Howard Taft and William Jennings Bryan visited. During its years as the Indiana State Teachers' College, notable visitors included Pres. John F. Kennedy, Adm. Richard Byrd, and Carl Sandburg. In the more recent past, since the school has become Indiana University of Pennsylvania, gaining prominence as the largest of the 13 state-owned universities, Carl Sagan, Pres. Jimmy Carter, and Ed Bradley have spoken.

Indiana has traditionally supported cultural events, through both the community and the university. Early groups such as the Shakespeare Club and a number of military and municipal bands have provided literary and musical entertainment. The opening of the Conservatory of Music in Thomas Sutton Hall at the Indiana State Normal School made available a much broader range of quality music to area residents. In later years, the development of the theater and fine art departments have produced and brought to campus an array of performances to suit every taste. Hollywood star Jimmy Stewart got his start acting in some of the university's Model Elementary School productions while he was a student there.

Other areas of recreation and entertainment were originally matters of necessity. Hunting and fishing played a vital role in Indiana's early history, providing sustenance to early settlers and wealth to later residents. Bounties were paid by county government for scalps and ears of various animals, allowing any number of pioneers in the area to purchase entire farms with their bounty payments. The county paid out $947 in 1814 for wolf scalp bounties. Prices in 1841 had risen to include 50¢ for a whole fox, $1.50 for a wildcat, $20 for a wolf, and $16 for a panther. John Leasure, one of the areas earliest settlers, is said to have bought several farms with the money he earned from wolf scalps captured in the Indiana area. Soon after, as communities developed, citizens of Indiana and surrounding towns frequently engaged in game hunts, during which record numbers of animals from sparrows to deer were killed in a single outing. One such was the popular squirrel hunt. In one day in 1828, a squirrel hunt killed 1,212 of the animals.

Organized sports have also had a part in shaping Indiana's character. In the late 19th and early 20th centuries, baseball teams were ubiquitous, with multiple teams in Indiana and in many of the smaller villages around the area. The mining towns around Indiana were almost always able to field at least one team, and the sporting rivalries between these teams were welcome breaks from the monotony and hard labor of toiling in the mines. Indiana's new streetcar system made travel to and from games in the various towns an easy trip. In more recent times, talented athletes from Indiana as well as students from the university have excelled in their sports. One such success was Indiana native Mike Ryan, who was recruited by the Minnesota Twins.

During the Great Depression, many businesses in Indiana sponsored baseball, basketball, and other sports teams in an effort to boost morale during this troubled time. Government-sponsored activities and Works Progress Administration projects also occupied Indiana's unemployed residents. Community endeavors were undertaken, such as the construction of a new Boy Scout mess hall and cabins at Camp Seph Mack, as well as an addition to the National Guard Armory on Wayne Avenue. Despite the difficulties of this period in Indiana's history, the bringing together of such a spectrum of the town's citizens to coordinate and complete these projects encouraged a strong sense of civic pride.

Not only is civic pride a vital component of Indiana's character, but national pride and patriotism have played just as important a role in the town's communal composition. Indiana has always answered the call to send men and women to fight in the nation's conflicts and has supported and welcomed local veterans. Many of Indiana's early settlers were Revolutionary War and French and Indian War veterans. More than 3,500 Indiana County residents served in the Civil War, and equally significant contingents have been sent to serve in U.S. conflicts since then. In 1923, the Doughboy monument was erected in Memorial Park to commemorate

the service of those from Indiana in World War I. More recently, additional memorials have been created to honor Indiana's military men and women in other conflicts. Those whose efforts were on the home front performed equally valuable efforts in these times of struggle. During World War I, Indiana's women made bandages and other supplies for the Red Cross on the second floor of Memorial Hall (earlier the Silas M. Clark House and later the home of the Historical and Genealogical Society of Indiana County). During World War II, schools and citizens in town bought and sold war bonds and gathered for scrap drives to aid in the war effort. In the meantime, Indiana's coal and rubber industries continued to manufacture these materials so vital to military success.

Residents of Indiana—from industrial workers and laborers to craftsmen, artists, and educators—have worked together throughout its history to build a vibrant and increasingly diverse community. Today, increased business, community, and institutional partnerships are helping to maintain the town's vitality and to expand opportunities and resources to residents and visitors alike. We hope this book provides a glimpse of the remarkable achievements and successes of Indiana's past and serves as inspiration for Indiana's future.

One

FROM FOREST
TO FOUNDRIES:
INDIANA BEFORE 1865

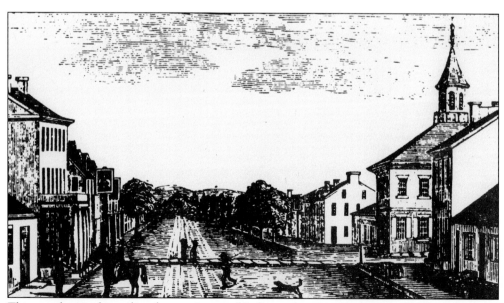

This woodcut is the earliest-known image of Indiana, showing the town in 1843. At the time, Indiana's population was only 700. The first courthouse, built in 1809, is shown to the right. It was razed in 1868 to make way for what would later be called the Old Courthouse.

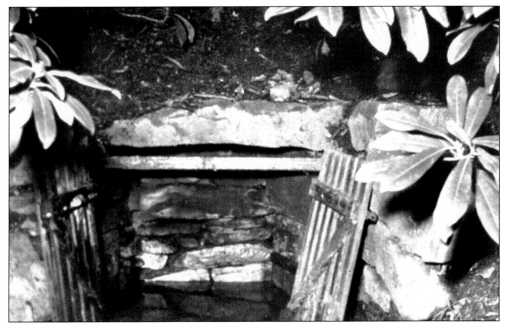

Trader Peter Shaver traveled through the Indiana area in the mid-1700s. The spring seen here was named Shaver's Spring after him and appeared on many early maps of the region. Located at the intersection of two Native American pathways, Catawba Trail and Kittanning Path, it was one of the frequent stopping places for travelers and early settlers.

In later years, Shaver's Spring was adorned with a plaque and featured prominently at the student union at Indiana State Teachers' College (later Indiana University of Pennsylvania). When the old structure was torn down to make way for the Hadley Union Building, the spring was blocked, and it is no longer visible to visitors.

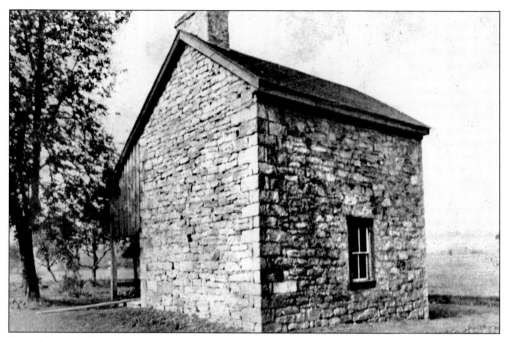

One of the earliest permanent structures in Indiana, this stone house was built by Fergus Moorhead c. 1792. He had come to the area 20 years earlier from Franklin County, as did many of Indiana's early settlers. It was built on the site of a blockhouse erected in 1781. By the 1970s, the house was in very poor condition.

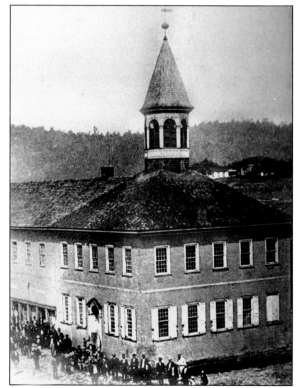

Indiana's first courthouse was completed in 1809. Some 20,000 wooden shingles were handmade for the building at a cost of $7.50 per 1,000. This memorial photograph was taken in 1868 just before the building was demolished to make way for the new courthouse at the same site, at the corner of Sixth and Philadelphia Streets.

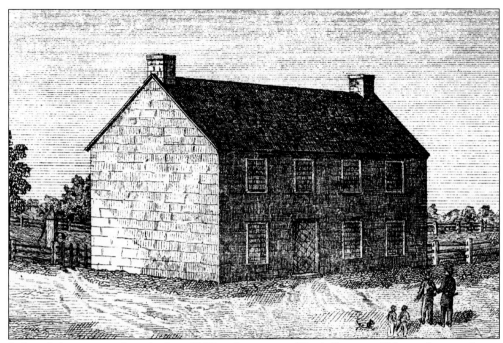

Indiana's first stone jail was built in 1807 at the corner of Sixth Street and Nixon Avenue. James Mahan was the stonemason, Thomas Sutton the carpenter, and Samuel Douglass the jailer. Early court sessions were held in the jail until the completion of the first courthouse in 1809.

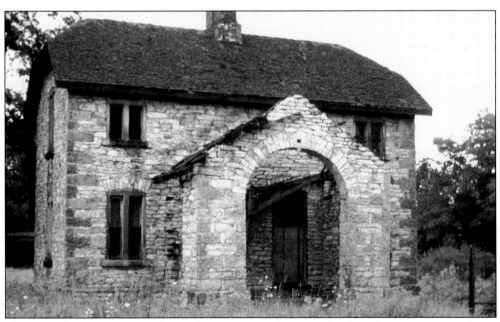

Thomas White was one of Indiana's best-known and respected early judges. He emigrated as a child with his family and came to Indiana as a young man in 1820. Within the next 10 years, he bought large tracts of land in several parts of the county. The gatekeeper's house, seen here, was built c. 1825 and was part of a large estate that White never got around to completing. Located in White's Woods, it was close to where his son Harry would build his own mansion, Croylands.

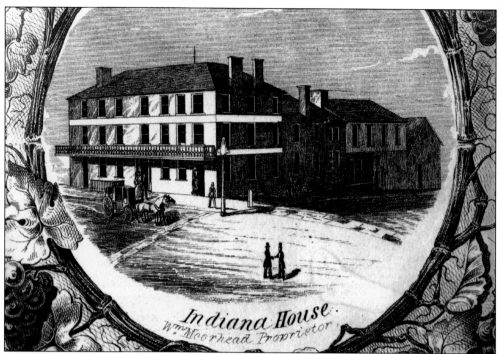

The Indiana House (later Indiana Hotel) is shown here *c.* 1856 when William Moorhead was proprietor. It was one of many hotels located in downtown Indiana, many of which lasted until the 1950s.

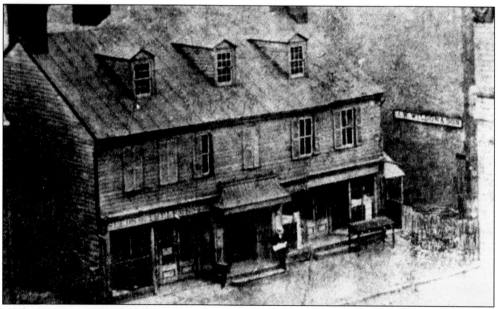

Within a year of Indiana's founding, Peter Sutton Jr. had built an inn near the corner of Philadelphia Street and Carpenter Avenue. The two-story log structure was later owned by George Kline and Charles Kline Jr. Seen here during this time period (*c.* 1880), it was called the Kline House and was run by the Klines' successor Alfred Fritz. In later years, the Classroom Restaurant operated at this location.

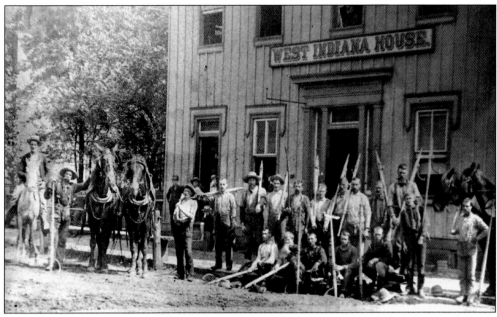

The West Indiana House was located on Philadelphia Street, several doors west of Ninth Street, the old dividing line between Indiana and West Indiana boroughs, which merged in 1895. These workmen holding cant hooks (for rolling logs) may be a crew staying at the hotel while working in town.

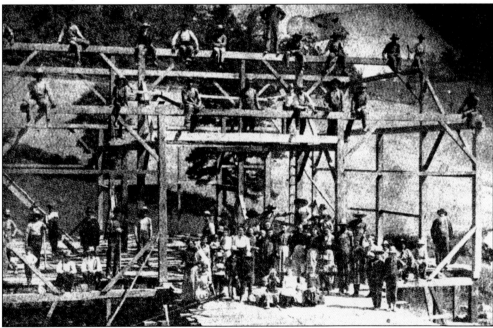

Early settlers in Indiana pulled together to help each other with large projects. Here, a group of men is gathered to spend a day at a barn raising. These sorts of all-day events ensured that a farmer never had to wait long to have protection for his livestock and harvested crops. Combined with communal meals, barn raisings brought neighbors together and made life easier for all.

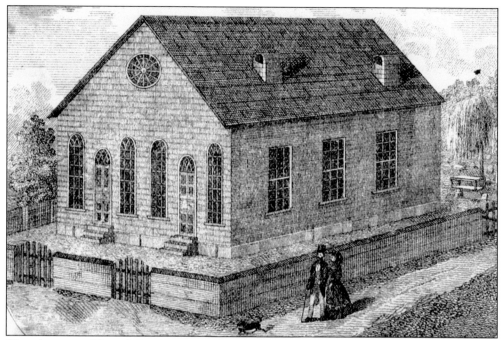

The Associate United Presbyterian Church (later the First Presbyterian and still later Graystone) built the structure seen here in 1827. It was the first permanent church building to be erected in Indiana borough.

Pictured is Indiana's Second United Presbyterian Church, located behind Brody's Department Store on Seventh Street. The congregation had petitioned the synod for a separation from the First United Presbyterian congregation in 1894 after a dispute over an organ. Their new church was dedicated on January 29, 1897. Forty years later, after the two congregations had reunified, the Brody family bought the building and lot to expand their store's operations.

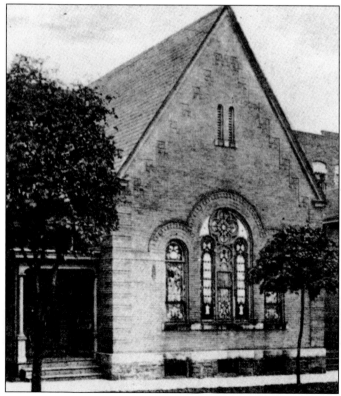

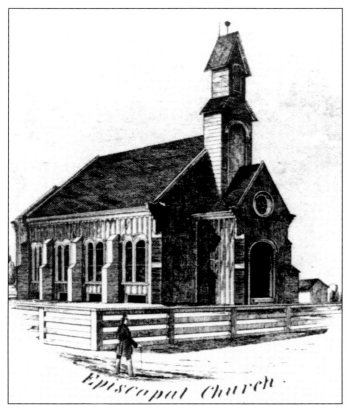

Episcopal Church.

In 1855, the Indiana Episcopal congregation erected this church. It lasted nearly 50 years, burning down in 1899, a year after some extensive renovations and the purchase of a $1,500 pipe organ. The rebuilt church, at the corner of Ninth and Philadelphia Streets, was dedicated in 1902 with a new $2,500 pipe organ donated by steel magnate Andrew Carnegie.

The First United Presbyterian Church was built in 1851 for $3,400, but the tower was not added until 1867. Graystone Presbyterian Church was later built on this site when the congregation needed a larger, more modern facility.

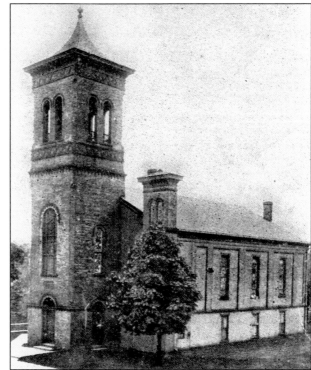

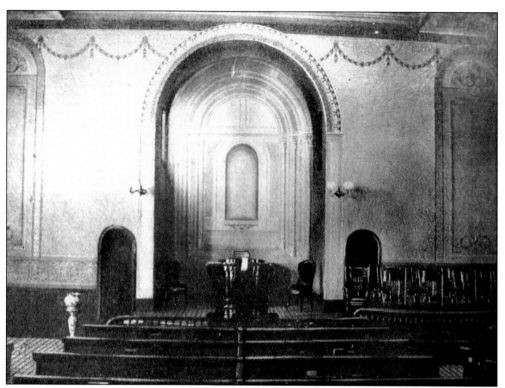

The interior of the First United Presbyterian Church is seen here. The elegant structure was considered by many to be the most comfortable and was the largest in the county when built in 1851. In 1909, the First and Second United Presbyterian congregations split in a controversy over the acceptability of the purchase of a pipe organ. The churches did not reconcile until 1936.

Until the early 1900s, almost all of the deliveries in town were made by horses and wagons like the 1870s rig shown here. Roads were often so muddy in town that drivers risked being fined for driving on the sidewalk rather than being trapped in the deep mud of the street. It was not until 1901 that the first automobile was used for deliveries in Indiana.

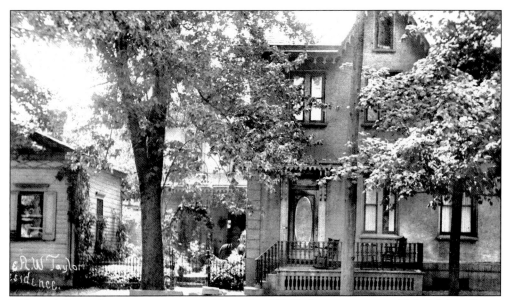

U.S. and Pennsylvania congressman Alexander W. Taylor grew up on Philadelphia Street between Fifth and Sixth Streets. A new family home, seen here, was built on the site in 1843–1844 and was one of the most elegant in town. Later Gov. John S. Fisher stayed there when he moved to town to attend Indiana High School and the Indiana State Normal School (later Indiana University of Pennsylvania). Years later, the home became the business place for Hawk's TV.

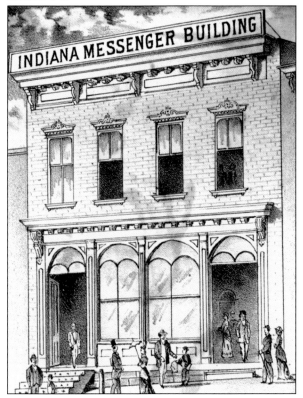

In 1861, the *Indiana Messenger* succeeded the *Democratic Messenger* under editor Clark Wilson. The paper's office, seen here, was also where the *Indiana County National*, a Greenback paper, was printed in the late 1870s. The *Messenger* lasted until World War II, when it ceased publication.

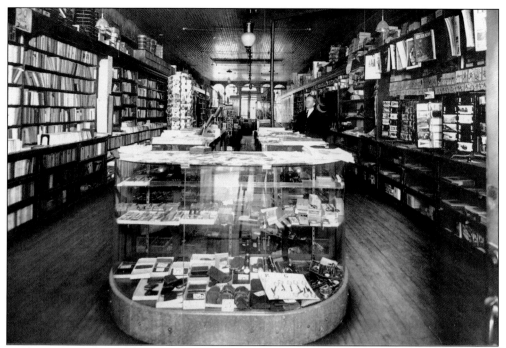

Henry Hall and his brother Charles W. Hall opened their store, Henry Hall & Brother, before 1866 on Philadelphia Street to sell books, newspapers, magazines, musical instruments, guns, ammunition, fishing tackle, and more. Although modernized, the store still operates at the same location to this day.

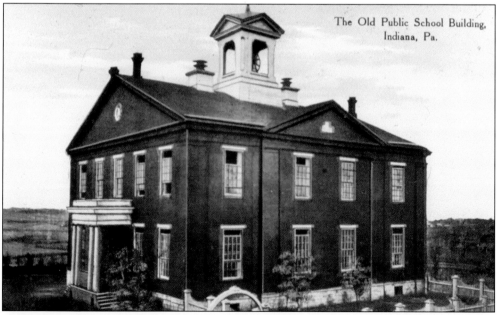

The Indiana Public School was begun in 1859, formally opening in September 1860. Located at Fifth and School Streets, it featured two playgrounds, a pump, six classrooms, and a lecture room with couches and lamps. There were 320 cherry desks and chairs and, in the tower, a 666-pound bell.

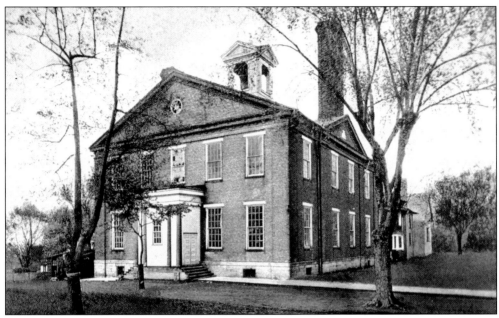

The old public school, later called the Second Ward School, is seen here. It was extensively remodeled in 1904, coming to have eight classrooms and a library. In 1909, the building was demolished and the new Second Ward School was built, later called Horace Mann Elementary School.

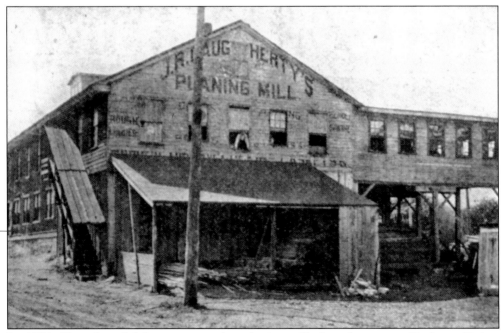

In 1854, Shryock and Johnston opened a planing mill, later known as Cochran, Ewing, & Company. In 1871, it was purchased by James R. Daugherty, whose son took it over in 1889. The mill, seen c. 1903, was doing a brisk business manufacturing sashes, doors, and blinds.

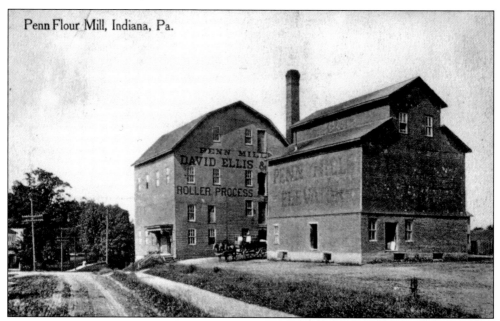

Penn Flour Mill, Indiana, Pa.

Located at Oakland and School Streets, the Penn Flour Mills opened in 1861. In 1894, production was 100 barrels a day. The same year, an expansion was built on the mill. Ten years later, production had doubled to 200 barrels a day. Flour was sold under a variety of brand names, including Imperial, Goldenrod, Victor Roller, and Tidal Wave.

Edward Nixon's home, built c. 1844, was located on Sixth Street behind the Old Courthouse. When the jail was being built in 1868, Nixon's storeroom was used for temporary offices. It was also Indiana's post office from 1885 to 1889 under Postmaster Fanny Nixon. Eventually, it was razed to make way for Delaney Chevrolet.

Looking east from Sixth Street, this view of Philadelphia Street shows the Houston House at left (later Houk's Drugstore, Gardner's Candies, and Sen. Patrick Stapleton's offices). William Houston's family immigrated from Ireland *c.* 1800 (when he was an infant), and he grew up to be a successful businessman in town, selling liquor and running a tannery.

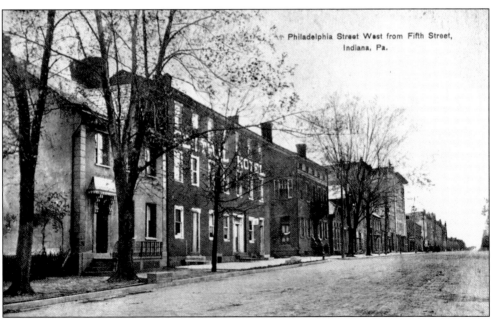

The Central Hotel was on Philadelphia Street between Fifth and Sixth Streets (later home to the American Legion). The first hotel on the location was opened in 1820 as the Black Horse Inn, owned by W.W. Caldwell. By 1876, it was the Farmers & Drovers Hotel, run by a Mr. Sweeney.

Dr. Robert Mitchell, an ardent abolitionist, was brought to federal court in 1845 on charges of harboring fugitive slaves who had escaped from Garret Van Metre in Virginia (now West Virginia). The prolonged case reached the Supreme Court, which rendered a final decision in 1854. Mitchell paid heavily in fines for his actions but maintained throughout the ordeal his firm antislavery beliefs.

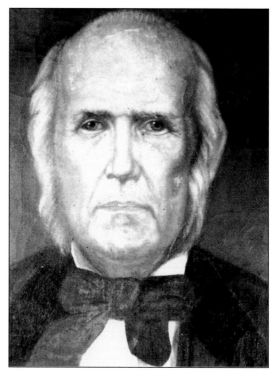

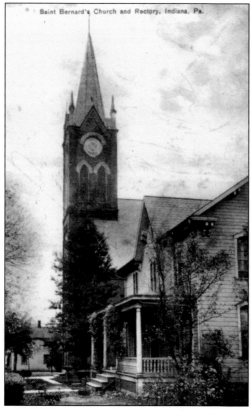

On August 17, 1869, the cornerstone was laid for St. Bernard's Catholic Church, seen here along with the parsonage, at the corner of Oak and Fifth Streets. It replaced the 1845 church, which had burned down in 1868, and was used until a new structure was built in 1979.

Winfield S. Shields (1847–1946) was Indiana's last surviving Civil War veteran, having served with Battery G, First Pennsylvania Artillery. His last public appearance was in the 80th Division Victory Parade after World War II, when he was nearly 100 years old. After his military service, he was active in the Grand Army of the Republic (GAR) and was a pharmacist in Marion Center.

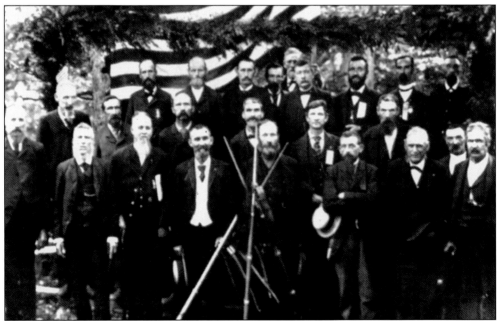

Seen here is a reunion of veterans of Company A of the 61st Regiment of Pennsylvania Volunteer Infantry. Many of these men were from Indiana and saw action throughout the Civil War. Cpl. John C. Matthews of this company was awarded the Congressional Medal of Honor for carrying the flag and colors while wounded at Gettysburg.

Two

Establishing a Legacy: 1865 to 1890

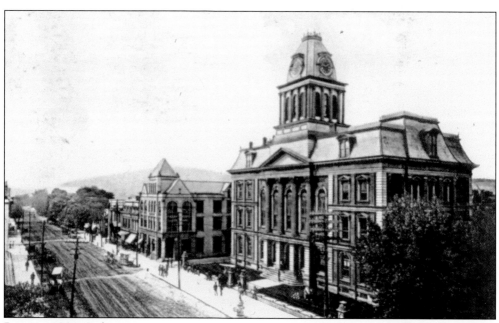

Prior to 1904, Indiana's streets were unpaved, as seen here. Even Philadelphia Street was deeply rutted. Electricity was making its way through town, and poles were erected with glass insulators, visible here in front of the courthouse.

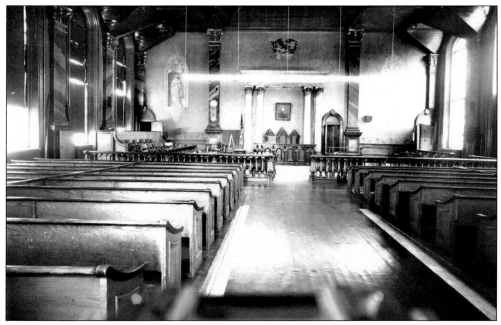

The courtroom of the Old Courthouse was an elegant facility, as can be seen in this photograph. Its stained-glass windows cost $1,000 c. 1870 and represented just one of the stylish inclusions of the architect, James W. Drum.

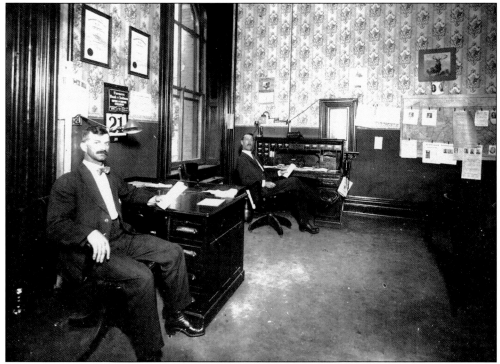

Shown here in the Old Courthouse are Deputy Sheriff Harry Williams and Sheriff George Jeffries in the late 1870s. Wanted posters cover the Pennsylvania map along the back wall.

Indiana resident Silas M. Clark was a Pennsylvania Supreme Court justice and a greatly admired man in Indiana. When he retired from public office, he continued to practice law from one parlor of his Victorian mansion at the intersection of Indiana's Sixth Street and Wayne Avenue (later called Memorial Hall and still later home to the Historical and Genealogical Society of Indiana County).

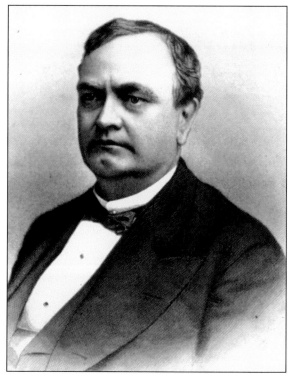

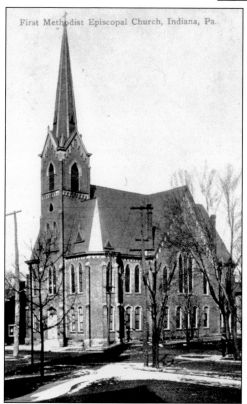

First Methodist Episcopal Church, Indiana, Pa.

In 1875, the Methodist Episcopal congregation began to build its new church. A new building was much desired, as the old building was rather unclean. In the 1860s, the old church's janitors routinely cleaned up as much as a half-gallon of tobacco quid from the floor after services. The new church's steeple was said to be the highest in town, soaring 142 feet.

Indiana High School's first class graduated in 1883. Shown here is the entire Class of 1895. Seated in the middle is Harry Earhart, first cousin of aviatrix Amelia Earhart.

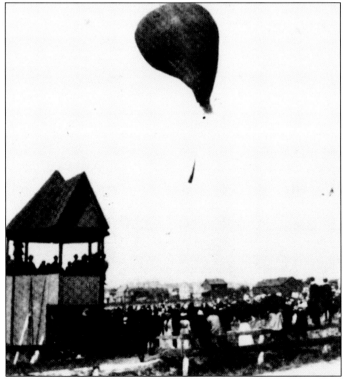

This 1881 photograph shows a hot-air balloon demonstration at the Indiana County Fair. Such demonstrations were popular at the fair. A "Professor Light" went up in 1873, and 13-year-old John Wise went up the following year. In 1890, ascensions were combined with parachute jumps from the high-flying balloons. Balloon races and the use of balloons to drop bombs (or the equivalents) were also popular spectacles for many years.

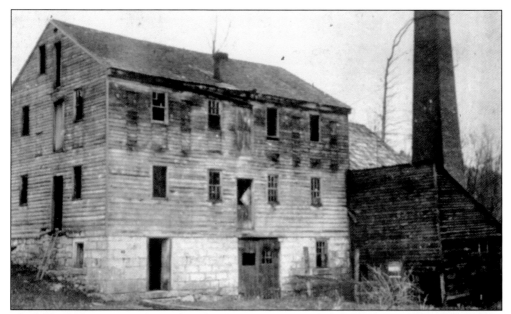

The late 1800s saw several strawboard mills in Indiana, including Sutton & Allison's. Solomon Hauxhurst, their manager, built his own mill (shown here) on Indian Springs Road. The strawboard was sold nationally and was frequently used in box making.

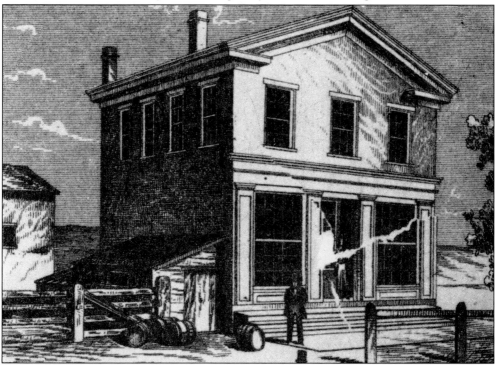

John H. Shryock was a member of one of Indiana's very first families. A successful businessman, Shryock owned a foundry, a steam-powered sawmill, and the store seen here. In 1858, he became one of the first trustees of the Indiana Seminary. This image comes from a map made in 1856 by David Peelor, county supervisor, who also taught surveying and engineering at the seminary.

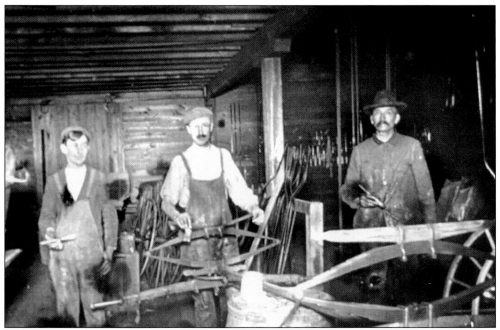

Isaac Beck opened his carriage works near the corner of Sixth and Water Streets in the late 1870s. For 40 years, he made buggies, milk and delivery wagons, carts, and hearses, employing as many as 32 men. One particularly elegant wagon was elaborately carved and outfitted in velvet.

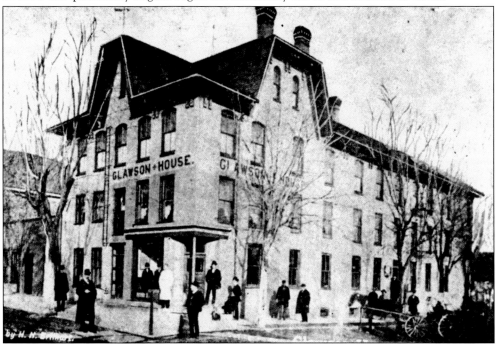

Seen here is the Clawson House. Originally built in 1876, the structure was called the Centennial Hotel and may have been so named in honor of the national centennial that year. By 1879, it was called Rieder's Hotel and was only a couple of blocks from A.J. Rieder's distillery. In the early 1900s, it became the Clawson House and, eventually, the Brown Hotel.

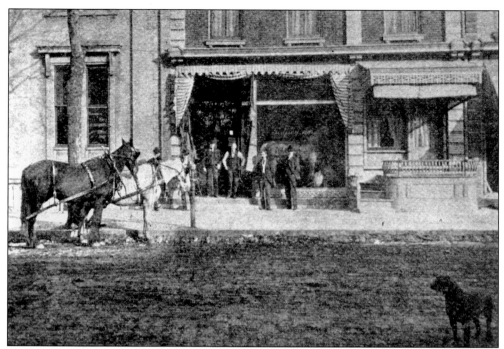

Godfrey Marshall, whose harness shop is seen c. 1900, was one of the early investors in the Indiana Street Railway Company. His shop was one of the largest and best known in the county since its opening in 1861, making him a well-to-do local businessman.

Roller-skating became popular in Indiana in the early 1880s. By 1886, however, interest was fading and several rinks had closed. The Church Street Rink was bought that year by a group of a dozen young men who wanted to build an opera house. They remodeled the building into the structure seen here, calling it Library Hall. The hall came to host plays, operas, lectures receptions, basketball games, more roller-skating, concerts, and early movies. It was eventually torn down to make way for the new structure housing the headquarters of the Rochester & Pittsburgh Coal and Iron Company.

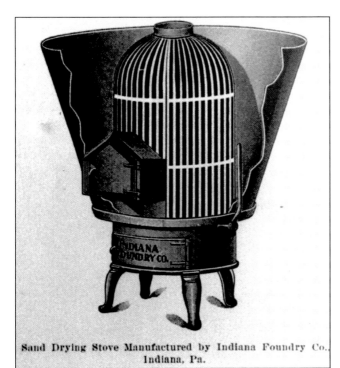

In 1916, the Indiana Foundry did a brisk business. One of its principal products was the Sutton Sand-Drying Stove, seen here. It was sold by the train car to railroads, coal companies, and trolley companies from Canada to South America and from the West Indies to Japan.

Sand Drying Stove Manufactured by Indiana Foundry Co., Indiana, Pa.

Indiana's first waterworks were supplied by a 325-foot well drilled by Joel and Gilmore Fink on Hood Hill on the west edge of town. Five and a half miles of cast-iron water mains in trenches three and a half feet deep were laid, and two tanks were installed that held a total of 300,000 gallons. Water service for town and firefighting needs was turned on in June 1887.

Shown in 1888 are some of Indiana's most promising young men, sons of prominent local families. Included are Will Hildebrand, Harry Gorman, David Blair, Ross Sutton, Harry White, Dick Wilson, Charlie Kline (later mayor of Pittsburgh), and Walter Jackson.

Several Indiana County business and political leaders are shown c. 1880. They include future Pennsylvania governor John S. Fisher (back right) and Elder Peelor (front right), a member of the Pennsylvania House of Representatives.

The Indiana Telephone Company was organized in 1887 with Matthew Watson as president. In 1895, businesses could purchase phone service for $2 per month, and a total of 40 phones were in operation by the end of the year. By 1904, the company built a new building, seen here, to support its 400 phones in the borough (plus 200 outside of town). It was located at the corner of Carpenter and Gompers Avenues.

This group of carpenters appears to be in front of the West Indiana House (later Houk Hotel). The picture was taken c. 1880.

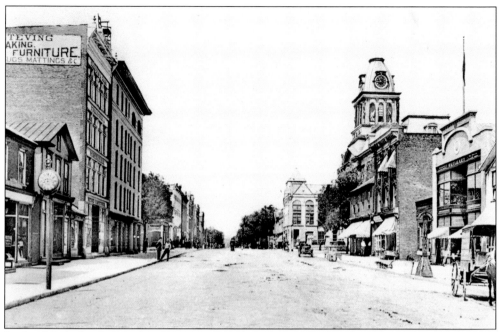

In the days before Indiana's citizens purchased many cars, the streets seemed much wider. Even Philadelphia Street was not paved until after 1904, and horses and carriages were quite common in town until the second decade of the 20th century, when cars began to grow more popular.

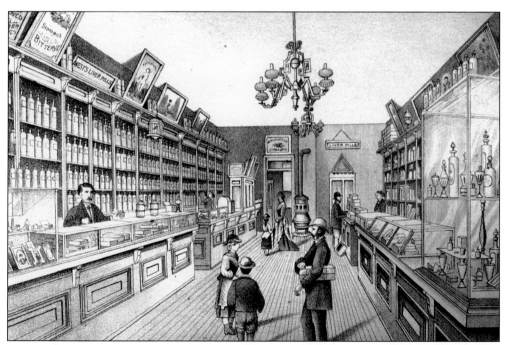

R.D. and Delos Hetrick came to Indiana in 1870 and opened the successful drugstore seen here. They were also the owners of the first automobile in the county in 1892, having built it in the barn of their Church Street home.

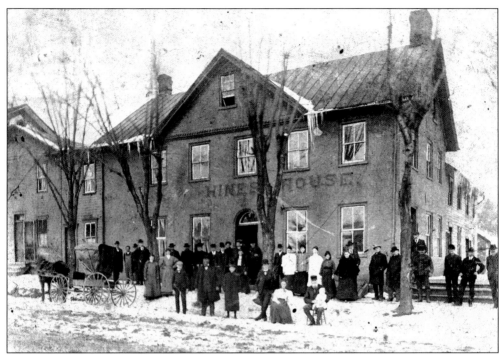

The Hines House hotel stood at the corner of Water and Fifth Streets and was originally called the Punxsutawney House, run by Conrad Bley. He sold it *c.* 1871 for $8,000, and sometime after that, its name was changed to the Hines House.

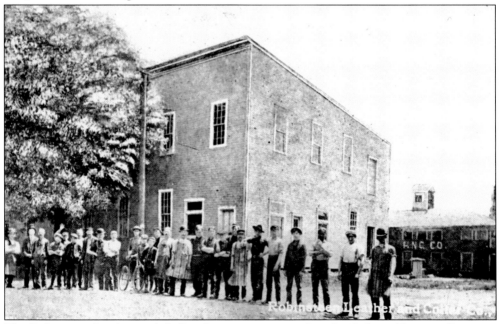

The Robinsteen Leather and Collar Company originated as the Indiana Tanning Company in 1884. C.H. Robinsteen, a Pittsburgh businessman, purchased the company in 1905. It was located at the corner of Third and Philadelphia Streets and, by 1908, had 50 employees, whose combined salaries amounted to $30,000 annually.

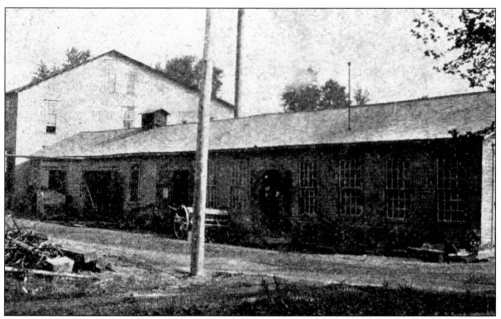

In 1879, Indiana native Edward Rowe invented the Bent-Rung Ladder, patenting it two years later. From his efforts came the Indiana Bent-Rung Ladder Company, located at the corner of South and Eighth Streets. The ladders were sold worldwide. In 1907, the company was producing 50,000 ladders per year. It closed in 1929 due to low demand.

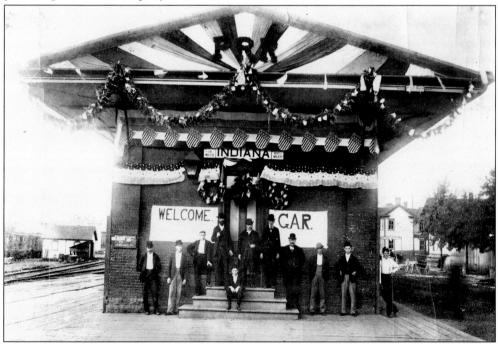

In the decades following the Civil War, the Grand Army of the Republic became active across the county. In addition to coordinating observances for Memorial Day, they organized many military reunions. One of the largest reunions was in 1886, when 2,000 veterans marched in a parade to the delight of thousands of spectators.

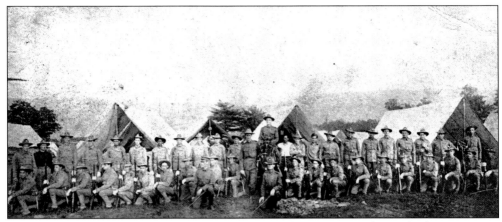

Here are the men of Company F, 5th Regiment, Pennsylvania National Guard. This active unit was called in 1877 to help quell the Railroad Riots in Pittsburgh. Commanded in part by Gen. Harry White, they set up camp across from the stockyards as well as near the coal mines east of the city for what was called the Mucklerat Campaign.

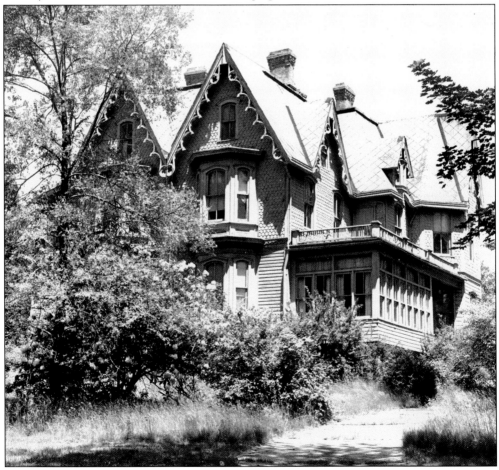

Croylands, the home seen here after some years of neglect, was built by Harry White in 1872 for a mere $6,000. The 13-room home was named after the White family's ancestral home in Ireland.

Three

A COMMUNITY BLOSSOMS: 1890 TO 1920

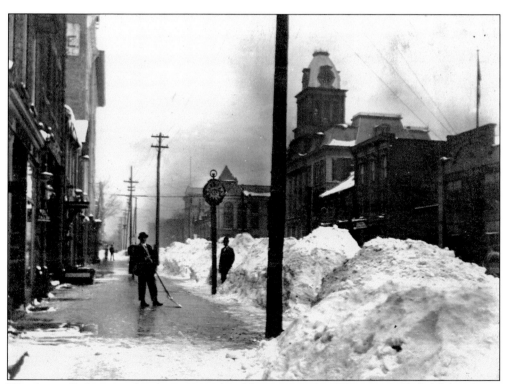

Weather in Indiana used to be as unpredictable as it is today. This snowy Philadelphia Street scene was taken to show the seven-foot snowstorm that fell on much of Indiana County in February 1914. Indiana County has also seen tornadoes, floods, blizzards, and droughts. Once, in 1897, residents felt earthquake tremors.

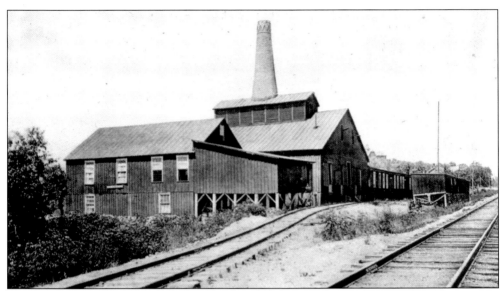

In 1892, the Indiana Glass Company began production of molded glassware but fell into debt soon after opening. The plant was bought out by Northwood Glass c. 1896 with Thomas Dugan as manager. The factory, seen here, produced the Diamond "D" glassware for many years. Its site was later the location of Indiana University of Pennsylvania's Miller Stadium.

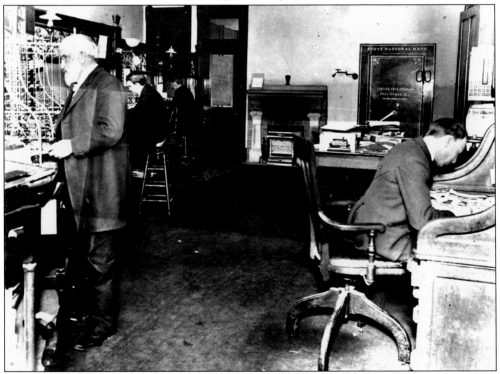

In 1898, the interior of the First National Bank shows several men hard at work. In 1864, robbers gained entry to the bank but failed to open the large safe seen here on the back wall. The bank later moved and built the large marble structure at the corner of Philadelphia and Sixth Streets.

This interior view of the Presbyterian church in Indiana was taken in 1904, just before the nearly 50-year-old church was demolished to build a new structure. The purchase of the pipe organ seen in the back had caused the congregation to split into two separate bodies.

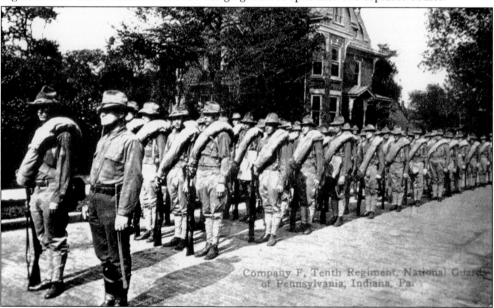

Pictured is Indiana's Company F, 10th Regiment, Pennsylvania National Guard. An active unit, they trained at Camp Hamilton in Lexington, Kentucky, during the Spanish-American War, served along the Mexican border in 1916 near El Paso, Texas, and were involved in many battles at the front during World War I.

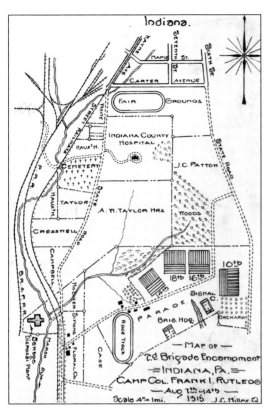

The National Guard encampment in August 1915 was held on the south side of Indiana on the Nealor Farm. Thousands of visitors came to "Camp Rutledge," and the governor inspected the camp. A demonstration of aerial bombing was probably the most popular event. Bags of flour were used for munitions to avoid any injuries at the affair.

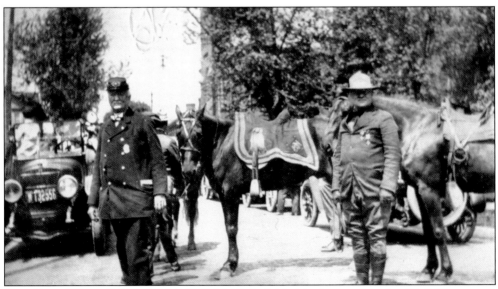

Gen. Harry White (left) and Maj. C.C. McClain (right) both served in the Civil War as part of the more than 3,500 men from Indiana County who fought for the Union. The two men are pictured in 1913, perhaps in connection with a reunion of the Grand Army of the Republic.

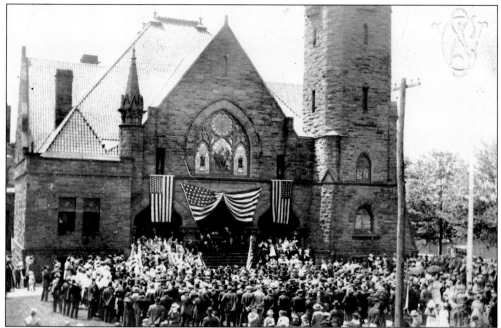

On Memorial Day 1917, this group is gathered in front of Calvary Presbyterian Church. The Grand Army of the Republic, which was responsible for organizing Memorial Day activities, missed the inaugural observation of the day in 1868, as the organization was not formed in Indiana until 1869. In the 1869 commemoration, Lincoln's Funeral March was played, the Grand Army of the Republic marched to this church, and a solemn ceremony was held.

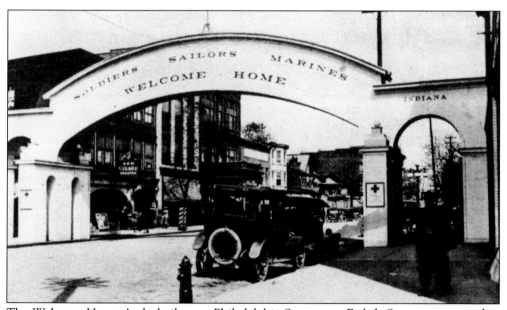

The Welcome Home Arch, built over Philadelphia Street near Eighth Street, was created to honor Indiana's citizens who served in World War I. The April 1919 dedication was on a rainy day, but the turnout was enormous, filling the streets.

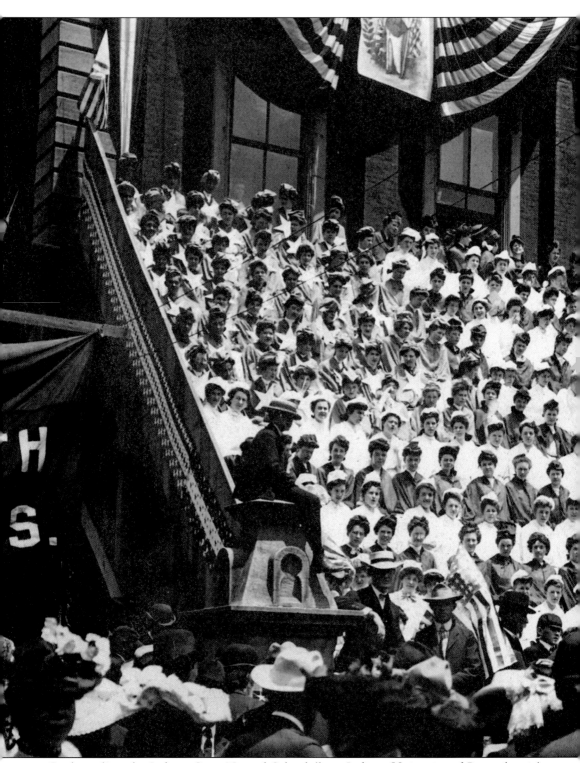

Students from the Indiana State Normal School (later Indiana University of Pennsylvania) turned themselves into this "living flag" on the steps of the Old Courthouse in celebration of

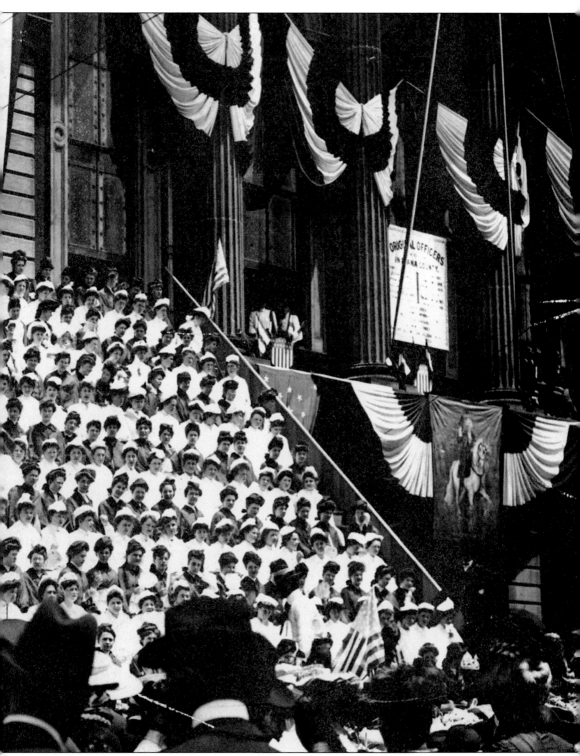

Indiana County's centennial in June 1903. A professional decorator was hired to adorn the town with banners and bunting.

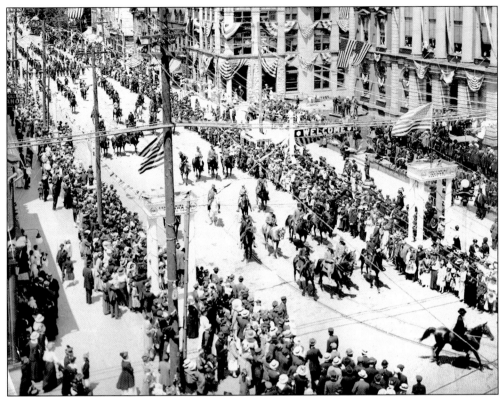

Exhibiting Indiana's strong sense of patriotism, this 1916 photograph shows the large turnout for the borough's centennial celebration, only 13 years after the county centennial. Military, civic, and school groups participated in the parade. Some attendees' enjoyment was spoiled by crime, and one gentleman lost $400 when his wallet was lifted by a pickpocket.

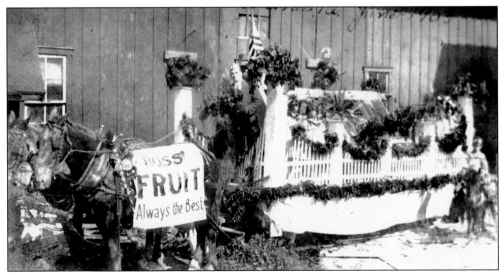

The centennial parade was a cause for great celebration, and it seemed that everyone participated. Seen here is the Ross Fruit Store's horse-drawn float, driven by Frank Morabito.

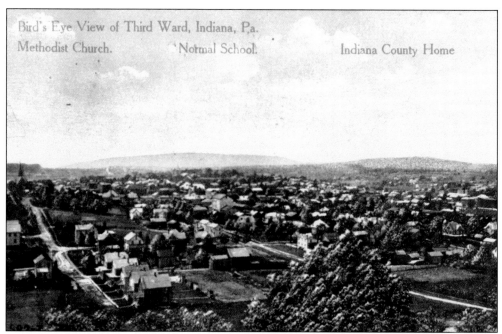

Bird's Eye View of Third Ward, Indiana, P.a.

Methodist Church. Normal School. Indiana County Home

Indiana's Third Ward is shown here in the early 1900s. Several of the noted buildings standing out are the Methodist church (left), the normal school (center), and the Indiana County Home, later Indian Haven (right).

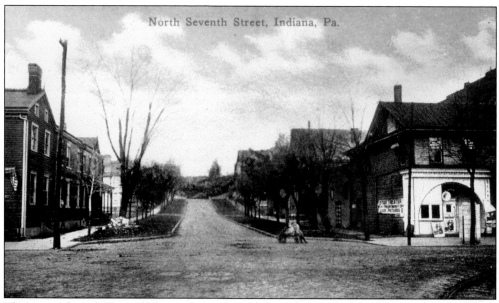

North Seventh Street, Indiana, Pa.

This view of north Seventh Street shows the old Star Theatre (right), which was run by Jacob Younkins and seated 150. It featured a scenic curtain and a huge star made of lights. In 1915, it was purchased to make way for the longstanding Brody's Department Store.

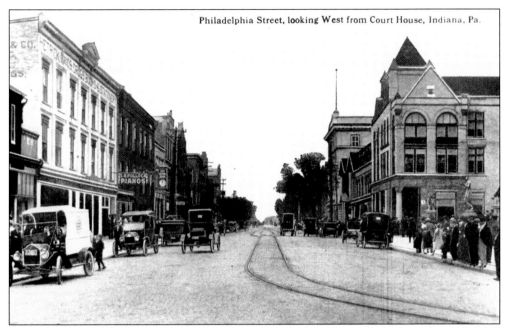

These views of Philadelphia Street, looking west (above) and east (below) in the early 20th century, show a few horse-drawn carriages as well as the newly popular automobile. In the eastward view, a recently introduced streetcar travels along the downtown tracks.

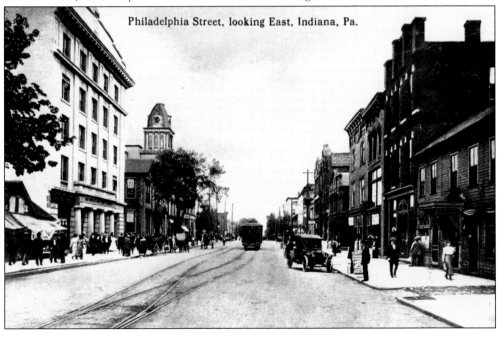

Philadelphia Street, looking East, Indiana, Pa.

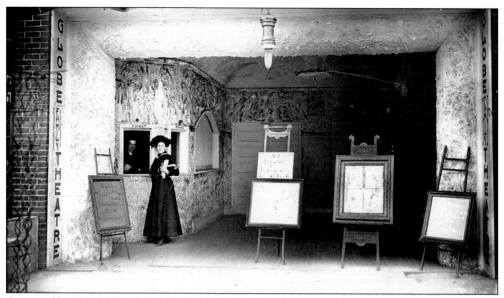

Operated by Frank Wood, the Globe Theatre, on Philadelphia Street just east of Eighth Street, had its grand opening in 1909. Most of its furnishings, including 400 opera chairs, survived a 1912 fire, after which the theater reopened at a new location. The theater was later called the Strand. Movies were only just becoming popular with Indiana's citizens.

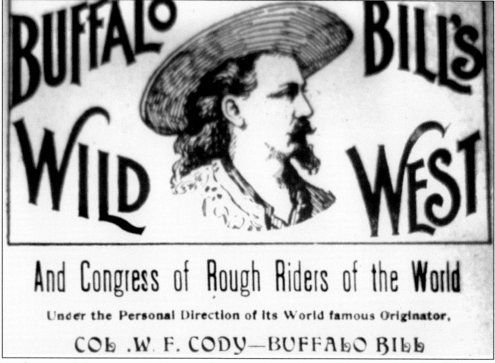

At the turn of the century, Indiana was large enough to draw such entertainers as Buffalo Bill's Wild West and Congress of Rough Riders of the World, who came on June 29, 1898. A local blacksmith, William Downey and his son Frank, shoed some of the show's horses while the touring group was in town.

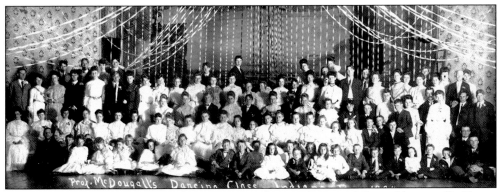

As the phonograph grew in popularity c. 1900, dancing became fashionable as well. Shown here is Professor MacDougall's dancing class for 1904.

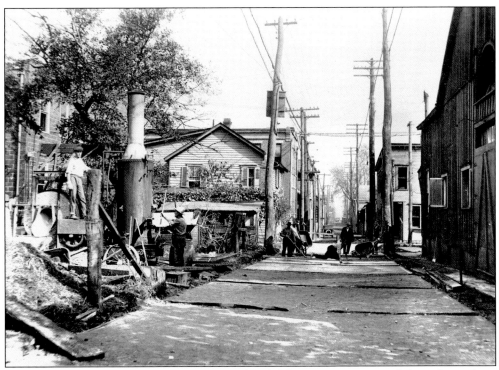

Roadwork in the borough was hard labor. Philadelphia Street was paved from Seventh to Eighth Streets in 1904 with vitrified brick, while Belgian blocks ran from Seventh to Fifth Streets. Everything else was macadam or clay in those years. This scene shows Gompers Avenue behind the current post office building.

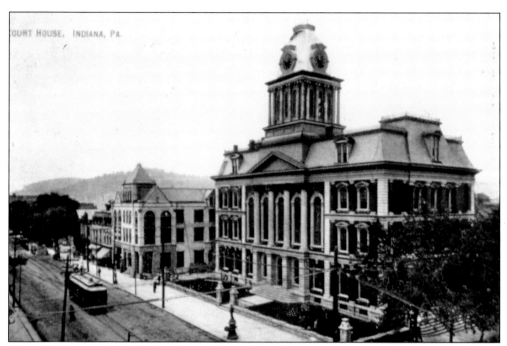

This c. 1905 view of the Old Courthouse shows the newly arrived streetcar system. Its miles of tracks were an inexpensive and speedy way for people to get around town and to outlying villages.

Indiana's streetcars also provided a way for people living in areas around Indiana to come to town for shopping, doctor's appointments, and events in the borough. The line to Clymer was completed in 1908. Seen here is an unidentified passenger (left) with Andy Salsgiver, conductor, and Fred Kier, motorman.

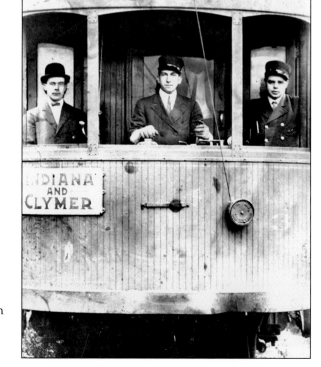

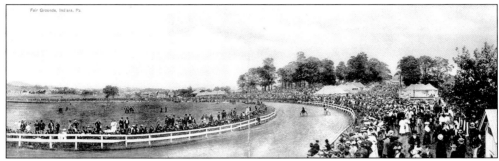

Fair Grounds, Indiana, Pa.

Racing on the track at the new Indiana Fairgrounds was popular after the grounds were opened in 1893 for a joint state and county fair. By 1905, two years before this picture was taken, attendance had peaked with a single day's visitors numbering more than 32,000. Early fair events included a petrified woman in 1896, a 1915 bomb-dropping demonstration, and a number of balloon and airplane flights.

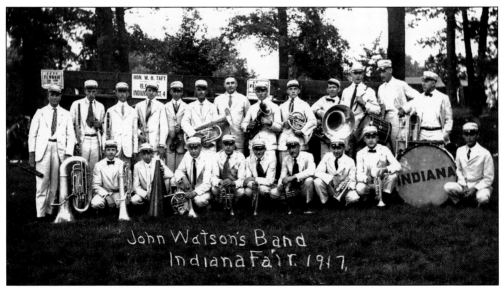

John Watson led one of the many popular bands to play through the years at the Indiana County Fair. The band is pictured in front of a sign advertising the upcoming visit of former president William Howard Taft, who planned to speak in favor of world peace.

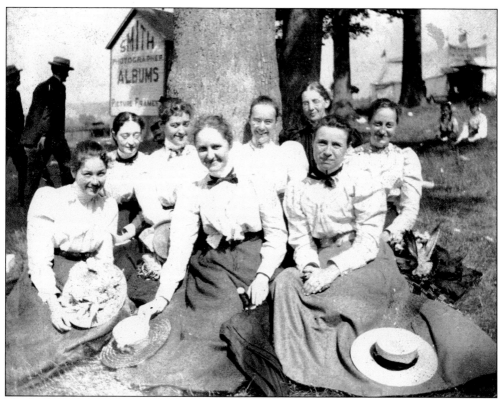

The Indiana County Fair was and remains one of the most popular events of the year. Here in 1895, these eight young women, perhaps normal-school students, pose in front of the Smith Photography barn at the fairgrounds.

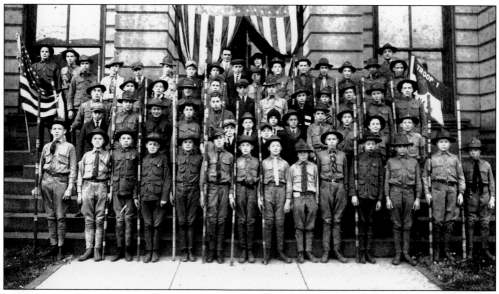

Indiana's Boy Scout Patrol No. 1 was formed on February 14, 1912, under leader Clark Keener. The Scouts frequently marched in parades organized to see off departing troops, such as draftees leaving in 1918 for Camp Lee. Here, they are pictured in front of the Old Courthouse.

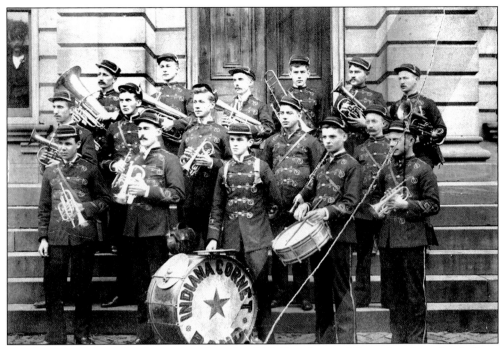

The Indiana Cornet Band is pictured at the Old Courthouse. They played at the Indiana County Fair for many years in the early 20th century. Local bands, especially military bands, were highly popular throughout the county during this time period.

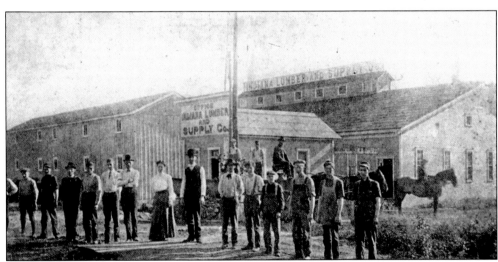

The Indiana Lumber and Supply Company was incorporated in 1903, soon building a two-acre facility at 10th and Oak Streets. The company made factory frames and sashes in addition to regular planing and millwork. By 1919, it was the county's 13th largest employer, with 25 workmen.

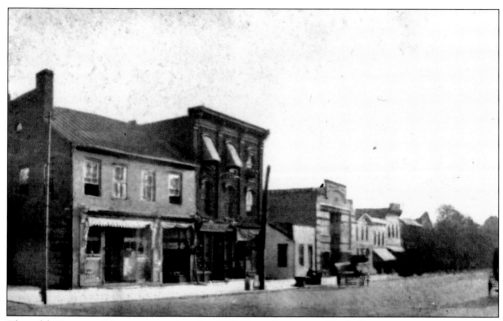

The old Houston House, opposite the Old Courthouse on Sixth Street, was at one point a pharmacy run by J. Howard Houk. Built *c.* 1840, it has remained one of Indiana's best examples of Federalist architecture.

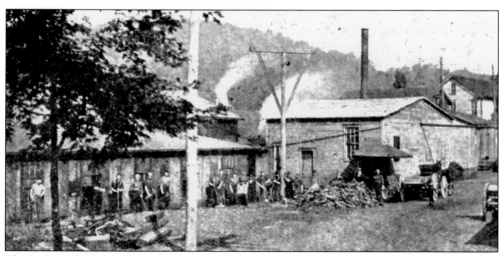

The Indiana Foundry Company, seen *c.* 1904, was originally opened as Sutton Brothers & Bell Foundry. In addition to metalwork, the company also sold Haynes, Chalmers, Detroit, and Hudson automobiles.

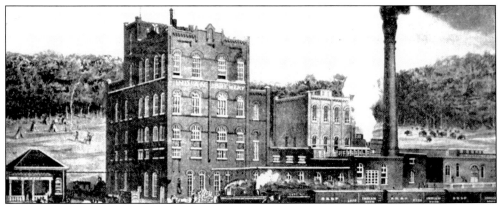

With the growing strength of the Temperance movement in the early 1900s, brewers and distillers such as the Indian Brewery (shown here) found it difficult to obtain licenses to sell their products. By 1910, they were in better shape, and that year, the brewery bought the largest truck ever seen in town to that point, able to haul six-ton loads at a top speed of 12 miles per hour.

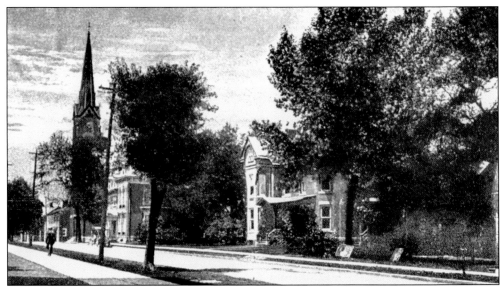

A westward look along Church Street toward Seventh Street shows the old Methodist church. The buildings along the right side of the street were demolished to make way for the new post office building in 1917.

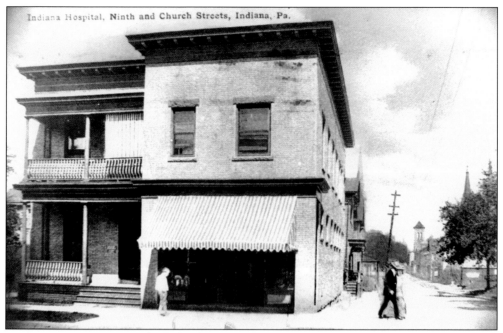

In 1908, Dr. G.E. Simpson built this brick building at the corner of Ninth and Church Streets, creating Indiana's first hospital. The grand opening in 1909 drew more than 500 visitors to the 10-bed facility. Featured in the hospital were an operating room, recovery room, waiting room, apartments for the nurses, and a two-floor porch used by patients and staff alike.

The new Indiana Hospital was opened several years later than local officials had planned. Funds were difficult to raise, and the project seemed impossible until coal magnate Adrian Iselin stepped in and funded the construction. Opening in 1914, the building was incorporated into later hospital structures on the site.

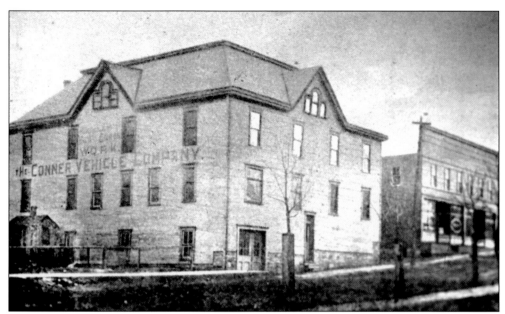

The Conner Vehicle and Carriage Company was located on 10th Street between Philadelphia and Church Streets. The one-acre plant employed 30 workmen to build spring vehicles and closed wagons. In 1908, a year after this photograph was taken, sales were $15,000. Eleven years later, when carriages were no longer in demand, the company was sold to First National Bank.

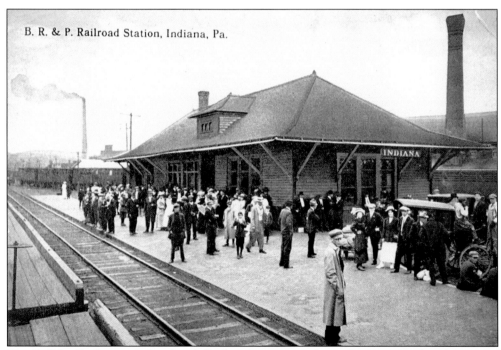

The Buffalo, Rochester & Pittsburgh Railroad came to Indiana County just after the turn of the century. On May 2, 1904, the first passenger train came to this station on Philadelphia Street between 11th and 12th Streets. In the first week of the Buffalo, Rochester & Pittsburgh's passenger service, 426 tickets were sold for destinations to the north of town.

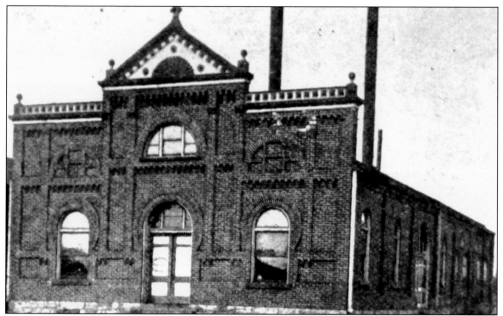

The Indiana Electric Company is seen here. The borough paid $55 per year for 23 arc lights to run in town. When the company was organized in the late 1800s, the power was supplied by a 100-horsepower boiler, a 125-horsepower compound engine, a 650-light alternating incandescent dynamo, and two arc machines.

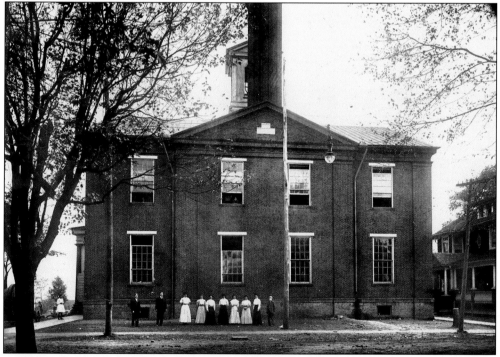

Completed in 1871, the Third Ward School was a typical facility of its day. Courses covered reading, writing, arithmetic, geography, and American history. Attendance was optional until the state legislated mandatory attendance in 1895.

In 1931, Indiana's Third Ward School was renamed the Thaddeus Stevens School. It was purchased by Indiana State Teachers' College (later Indiana University of Pennsylvania) in 1963. Shown here are the students in 1908 with their teacher, Edna Sanson Bathey.

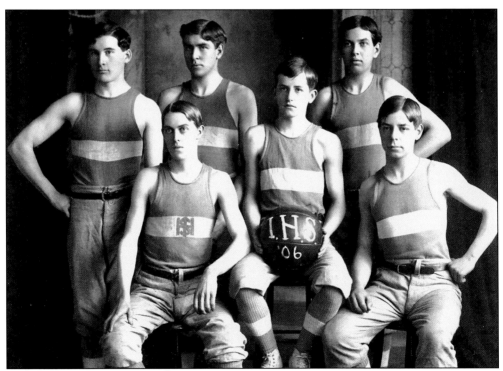

Indiana High School had a noted basketball team. The 1906 squad is seen here. At the time, baseball was more popular than basketball was, and nearly every town and village fielded a team. Football, track, and relay races were also popular in the early part of the century.

Four

BUSINESS AS USUAL: 1921 TO 1935

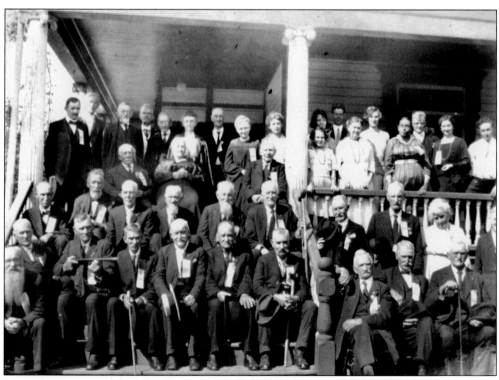

In 1922, survivors of the 55th Pennsylvania Volunteer Regiment gathered for a reunion. They were commanded by Col. Richard White, brother of Gen. Harry White.

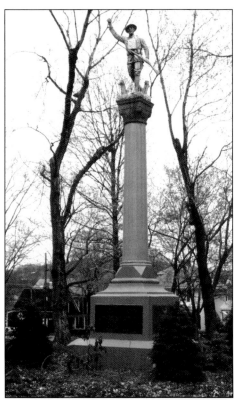

In 1923, the Mothers of Democracy pushed for a monument to World War I veterans in Memorial Park. The Farmer's Bank donated the marble corner column from its building as the pedestal. Vernon Taylor purchased the statue, and Jimmy Stewart's father, Alex, led the charge to erect the monument. Winning out over substantial controversy, the Doughboy monument was finally dedicated on Memorial Day 1925, with Indiana resident Gov. John S. Fisher giving an address.

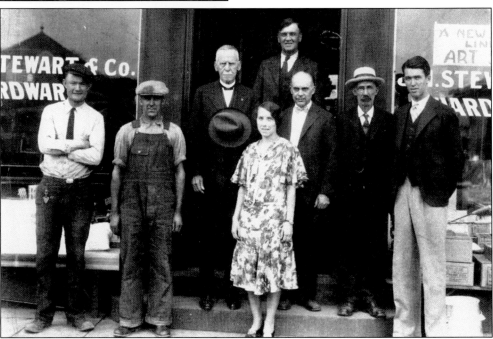

Seen here in 1931 in front of Stewart's Hardware are, from left to right, Robert Brady, Clair Doty, J.M. Stewart (Jimmy Stewart's grandfather), Aleatha Beatty, Alex Stewart, Walter Wiggins, George Little, and Jimmy Stewart.

Gov. John S. Fisher was born near Plumville in Indiana County in 1867 and served as Pennsylvania's governor from 1927 to 1931. Fisher Auditorium on the Indiana University of Pennsylvania campus was named in his honor. Interested in history, he also served a term as president of the Historical Society of Western Pennsylvania. He retired to a stately mansion on Indiana's north Sixth Street.

Local businesses and political leaders may be gathered here in honor of John Fisher's announcement that he would run for governor in 1926. Pictured are, from left to right, Ross M. Sutton, Alex Stewart, attorney B.M. Clark, Pittsburgh Mayor Charles Kline, Harry White Jr., and John P. Laughlin.

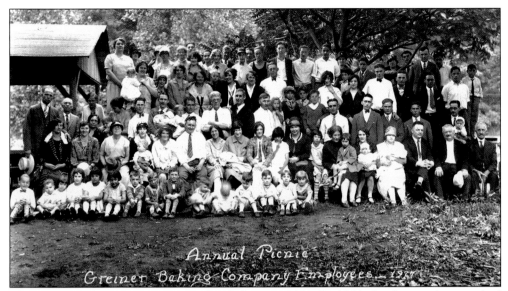

The Greiner Baking Company opened in Indiana in 1908. By 1941, the thriving business had moved to the abandoned Indian Brewery building. The company continued until 1960, when it was closed and sold. The old brewery structure was sold six years later to the Kovalchick Salvage Company, which demolished the derelict building several decades later.

This photograph of the Indiana Kiwanis Club shows the members of the then nine-year-old civic organization on August 7, 1933. The following summer, they sponsored a popular passion play at the fairgrounds.

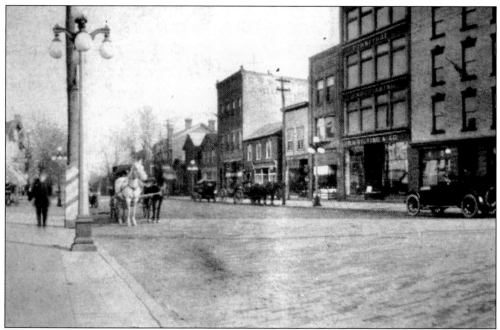

In the early 1920s, as this scene of Philadelphia Street between Fifth and Sixth Streets shows, horses and carriages were still common sights. In the distance on the far side of the street is the A.W. Taylor home, later Hawk's TV, thought to be the oldest standing building in Indiana.

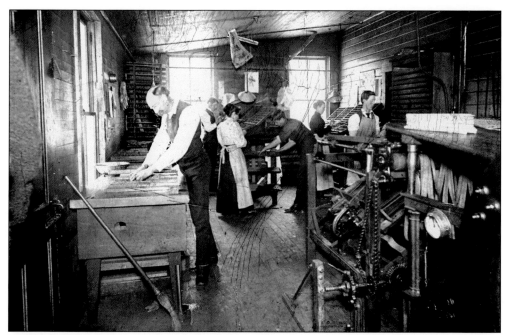

Shown here is the pressroom of the *Indiana Times* in its early days. The paper was first published on September 12, 1878, and continued for nearly 50 years until its demise in 1927. Although the printing was by machine, the metal type for each letter on every page had to be painstakingly laid out by hand—a very time-consuming task.

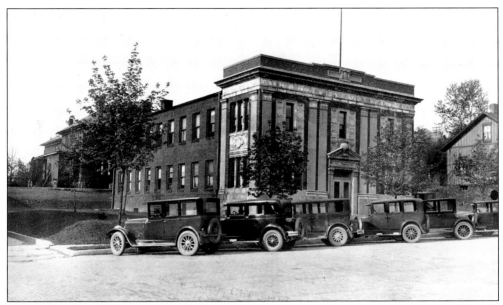

This is the Clearfield Bituminous Coal Corporation headquarters, built at the corner of Eighth and Water Streets in 1920. The corporation owned lands mostly in the northern part of the county and built the towns of Rossiter and Barr Slope, among others.

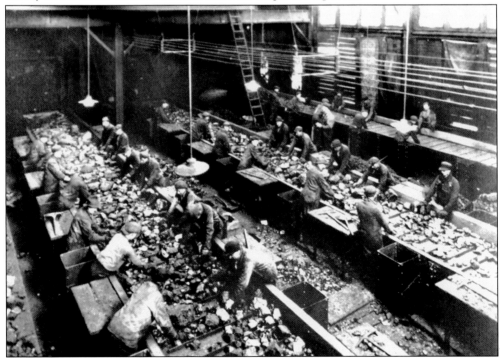

Coal companies such as the Clearfield Bituminous Coal Corporation and the Rochester & Pittsburgh Coal and Iron Company often employed children at their mines to sort coal before laws forbade their working. In this scene from the Lucerne mines, coal is sorted in the building known as the tipple. Undesirable materials such as rock and shale were removed from the cartloads of coal, which were brought out of the mine.

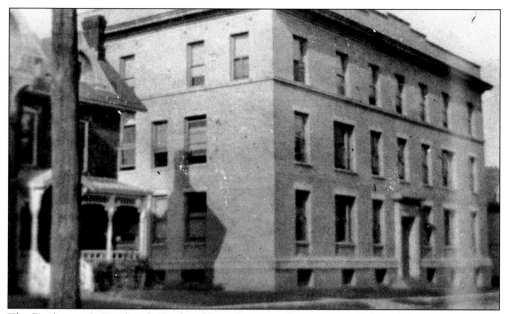

The Rochester & Pittsburgh Coal and Iron Company became one of the area's most prosperous businesses. In 1918, the company purchased Library Hall, razed the old building the following year, and erected its new corporate headquarters on the site. Its new building, shown here in 1921, is located across Church Street from the Presbyterian churches.

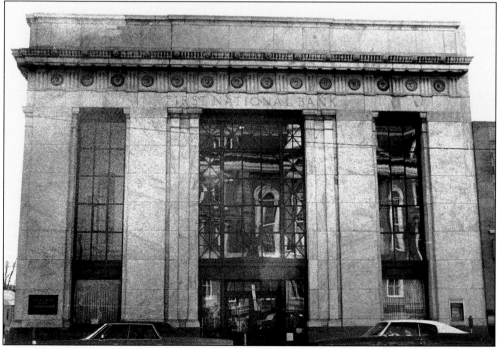

In 1921, First National Bank purchased a lot at the southwest corner of Sixth and Philadelphia Streets, across from the Old Courthouse, to build a new bank, which opened in 1929. Coincidentally, this was the long-ago site of Indiana's first bank, opened by John Hogg in the early 1850s.

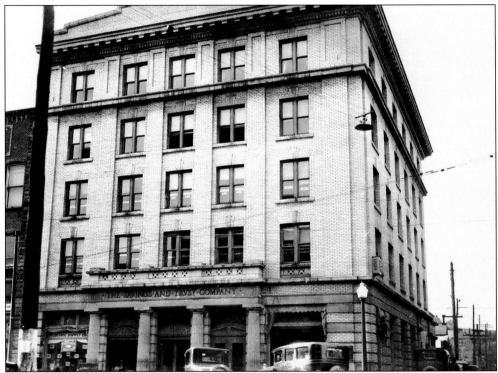

The Savings & Trust building was completed in 1910 on Philadelphia Street, six years after the bank's opening. It was forced to close briefly during the 1933 bank holiday declared by Pres. Franklin D. Roosevelt but was one of the first to reopen on March 15 of that year, surviving the perils of the Great Depression.

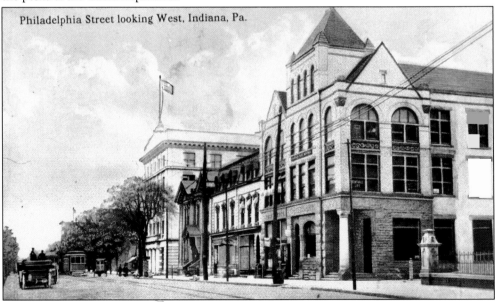

Philadelphia Street looking West, Indiana, Pa.

Seen here is the Farmer's Bank, adjacent to the Old Courthouse. It was built between 1893 and 1894 and also housed some offices along the alley side of the building, including that of attorney (later district attorney) W.H. Wood in the 1930s.

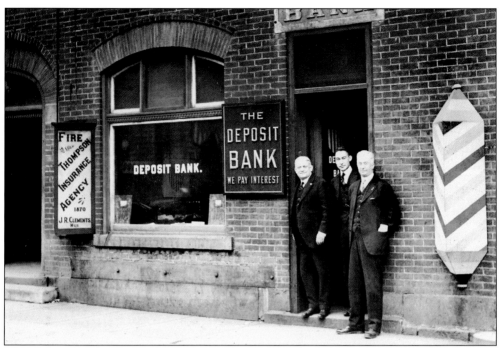

The Indiana Deposit Bank was organized in 1869 and weathered the ups and downs of the economy as well as local scandal, only to be liquidated in 1933 during the Great Depression. Pictured in November 1917 are, from left to right, Thomas Hildebrand, vice president; W. Clarence Fleck, cashier; and Harry White Jr.

Indiana's old Bon Ton store, seen here, was once located on Philadelphia Street between Seventh and Eighth Streets. In 1918, its new building was erected opposite the Moore Hotel by owner S.W. Rose. A popular downtown shop for decades, it was forced to close in 1937.

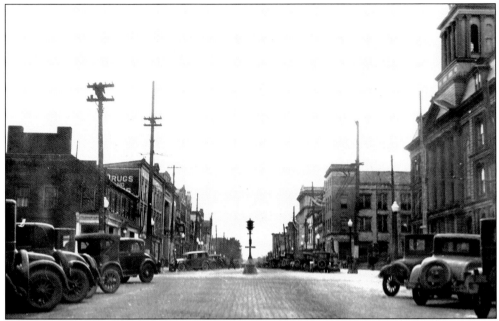

Looking westward along Philadelphia Street, this image shows the rapid rise in automobile popularity in the early part of the 20th century. In 1928, the county had nearly 16,000 registered vehicles. Car prices around that time ranged from $298 for a Ford touring car to $4,600 for a Lincoln sedan.

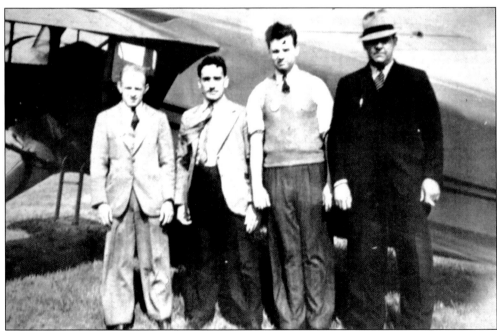

Indiana's first airfield was Hamilton Field, located on East Pike. A hangar was added in 1929, and daily flights went between the field and the Curtis-Bettis Airport near Pittsburgh in 1930. Charles Lindbergh landed at Hamilton Field that same year. Jimmy Stewart flew in to visit his parents, using the railroad lines to navigate his way here from Hollywood.

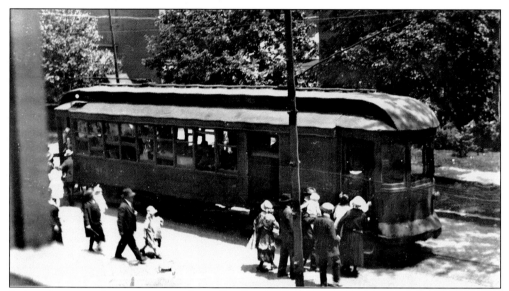

Indiana's street railway service was first offered in 1907, with routes leading to Ernest, Blairsville, and Clymer for a total system of 36 miles of tracks. Traffic peaked in 1923 only to drop to one-tenth that level 10 years later. The company was dissolved in 1936 as automobiles took over.

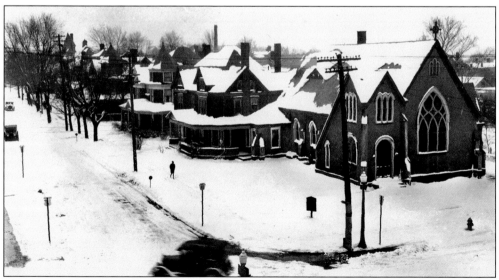

This 1920s scene shows the corner of Ninth and Philadelphia Streets and features the Episcopal church. The photograph was taken from the YMCA building, which later became the Indiana Free Library and home of the Jimmy Stewart Museum.

As with the rest of the country, Indiana saw hard times during the Great Depression. Sports leagues were an escape from desperate days, with local businesses and individuals sponsoring many teams. The Indiana Buicks, seen here in 1932, were a basketball team owned by Jim Kring and coached by Ken Kerr.

Kerr's baseball team was one of the many local sports leagues popular during the Great Depression. This team won the city championship for three years in a row, from 1932 to 1934.

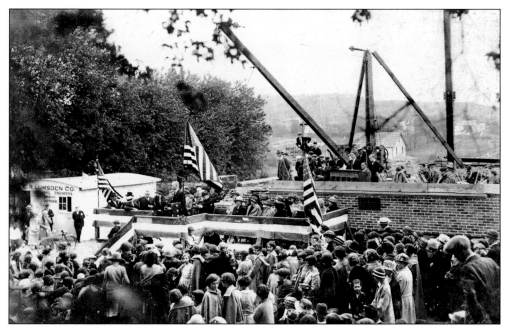

This photograph, taken on June 4, 1924, shows the ceremony for laying the cornerstone of Indiana High School (now Indiana Junior High School). The building cost $450,000 to construct, funded by a bond issue that narrowly passed in 1933, with 1,021 supporting votes and 921 against.

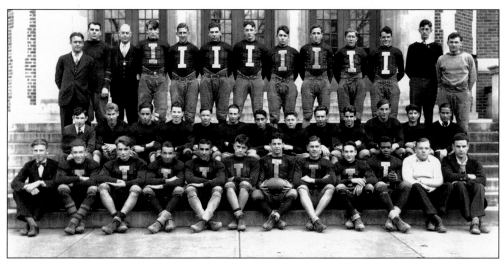

School sports, especially football, grew in popularity through the early 20th century in Indiana. Seen here is the 1930–1931 football team at Indiana High School. In the back row, second from left, is head coach and science teacher Joe Shane, one of the school's most beloved teachers.

In 1924, the Zion Lutheran congregation built a new church, soon after which this picture was taken. Lutherans and Presbyterians made up most of Indiana's early settlers, and the first Lutheran burial ground in town was located on what became Memorial Park.

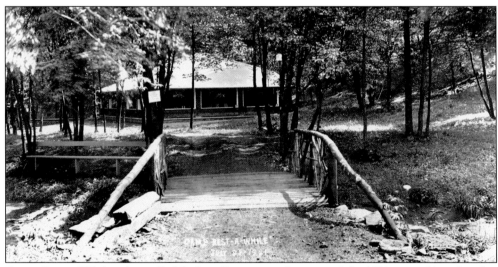

Camp Rest-a-While, also called Indian Springs, is shown in July 1921 several weeks after opening. A popular park, it grew to have a large swimming pool, paved walks, bathhouses, a sand beach, and more on its seven acres. Sold at a sheriff's sale during the Great Depression, it reopened to add a clubhouse, picnic grove, tennis courts, and playground. It later featured orchestras and dancing but closed in 1942 to make way for Federal Laboratories' production of war materials.

Five

IT'S A WONDERFUL TOWN: 1936 TO 1945

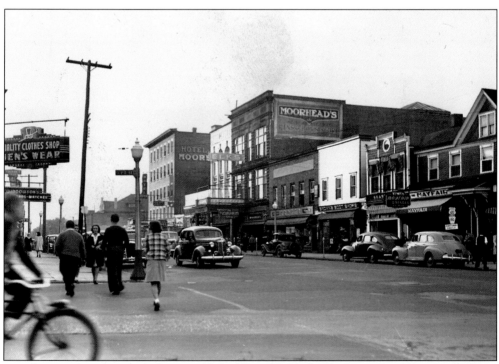

Seen here in the years just before World War II, Indiana's downtown crossroads at Seventh and Philadelphia Streets was popular with shoppers. Pictured are Widdowson's Jeweler's, Quality Clothes Shop, Mayfair Dress Shop, Brown's Boot Shop, Florsheim Shoes, Moorhead's Store, the Moore Hotel, and others.

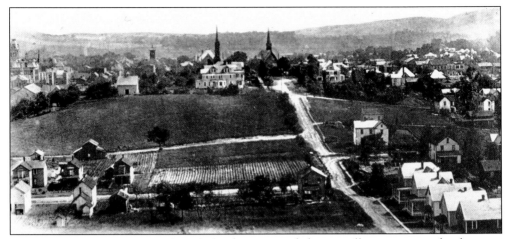

Round Top, the hill at the north end of Indiana, provided an excellent viewpoint for this view of town in the early 20th century. Within a few years, the fields seen here along Ninth Street were filled with homes.

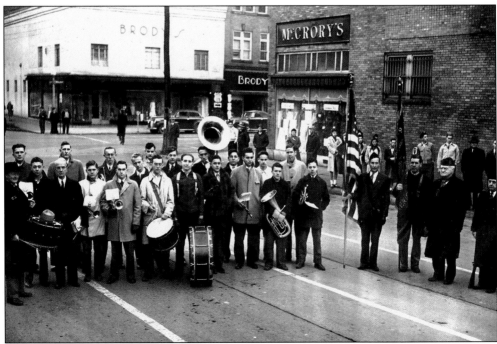

Bert Lichteberger (far left with drum) was burgess of Indiana from 1928 to 1942. He had served on the welcoming committee for Admiral Byrd's 1930 visit and loved to play in the municipal band. He is seen here in his last appearance with them, barely a month before his death.

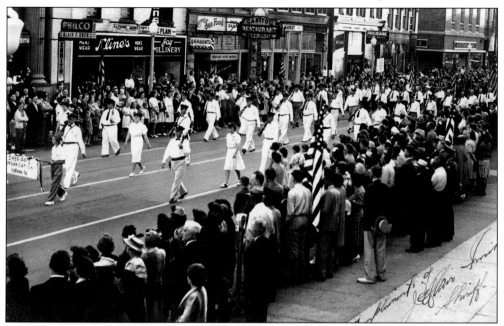

J. Clair Irvin, who signed this photograph, was sheriff when the Sheriff's Association marched through downtown as part of the 1942 Flag Day parade. Renewed patriotism following the attack on Pearl Harbor brought out especially large crowds.

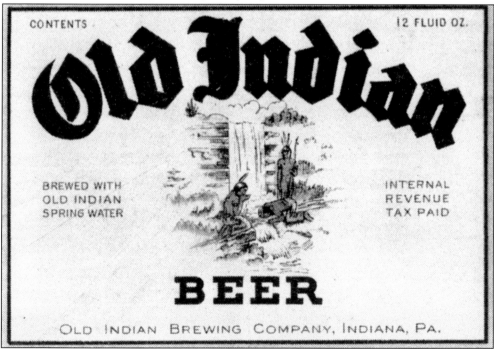

Old Indian beer was the popular local brew from the Indian Brewing Company (later home of the Greiner Baking Company). Due to regulations on the amount of beer it could make during Prohibition, the company saw a dramatic drop in its production volume. By 1937, however, the company had resumed making 37,000 bottles of Old Indian beer per day.

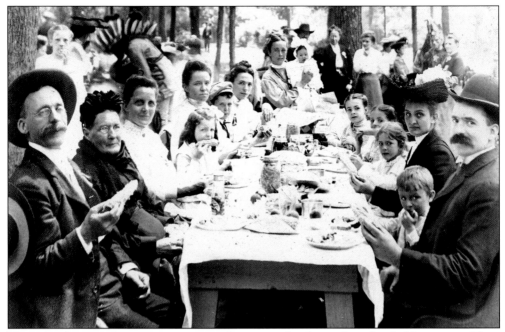

The annual county fair was an occasion when many families gathered to hold reunions. Here, the Pierce family meets for a picnic at the old fairgrounds. In the late 1920s and early 1930s, fair attendance was very low and some were cancelled. In 1935, however, efforts were under way to revive the traditional end-of-summer celebration.

Philadelphia Street is shown here in the late 1930s. Above the Indiana Theatre (left) is a sign urging voters to choose Joseph Guffey, a U.S. senator who campaigned with John L. Lewis in 1936 in support of Franklin D. Roosevelt's presidential bid.

In honor of his son Jimmy Stewart and others serving in the military from Indiana, Alex Stewart arranged and paid for a 10-foot-high V for victory to be mounted atop the courthouse in July 1941. It was lit on March 9, 1945, after some repair work and not again until Germany surrendered to Allied forces in May 1945.

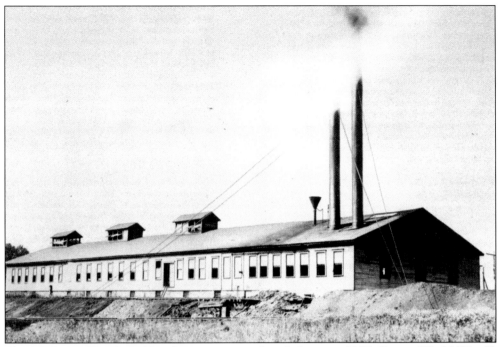

The McCreary Tire & Rubber Company opened in Indiana in 1915. During World War II, it was one of the few county industries to be awarded a war contract. A new building was authorized, and the company helped to supply the tires critical to the U.S. Army's efforts.

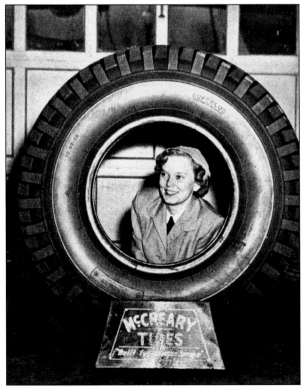

In the postwar years, the McCreary Tire & Rubber Company continued to be an active contributor to the Indiana community and to the Indana State Teachers' College (later Indiana University of Pennsylvania). The advertisement seen here shows the company's sponsorship of *The Oak*, the school's yearbook. The college-university community has traditionally made up a large portion of the business for those located close to campus.

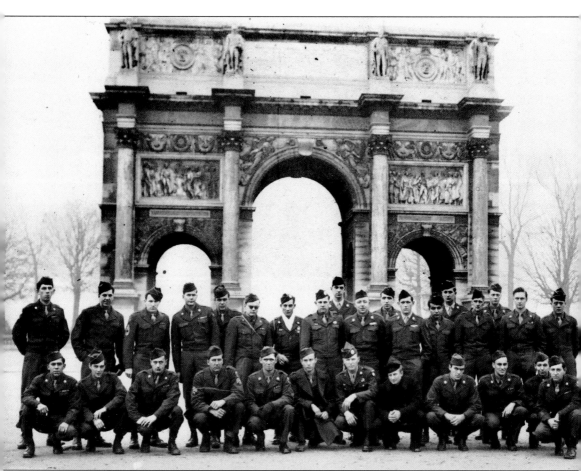

This group of GIs at the Arc de Triomphe in Paris includes several men from Indiana, such as S.Sgt. Bill Wood (second from right in the back row). They are representative of the many soldiers whose battles overseas were aided greatly by the work of companies that had war contracts (such as McCreary Tire & Rubber) and by the efforts of those on the home front who followed rationing guidelines, bought war bonds, and donated to scrap drives.

This house was built in 1807 on the site later occupied by the Savings & Trust Bank on Philadelphia Street. The Savings & Trust was one of the many banks forced to close in town when Pres. Franklin D. Roosevelt declared a four-day bank holiday during the Great Depression.

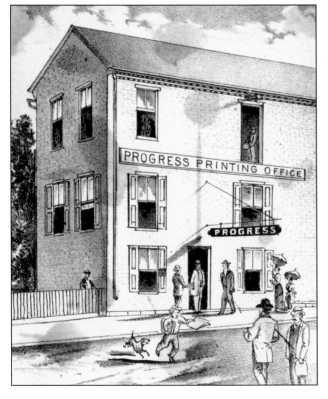

The World War II era saw the demise of many of Indiana's newspapers. The *Indiana Progress* was published in town from *c.* 1870 until 1946. During most of its run, it was owned by the Moorhead family.

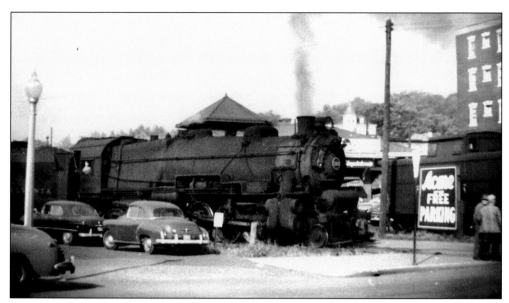

Passenger service on the Indiana branch of the Pennsylvania Railroad started in 1852, and traffic was heavy between Indiana and Blairsville as well as to points east, including the daily "Mountain Goat" route to Cresson. In 1940, passenger and mail service ceased on the line, and the station at Philadelphia and Eighth Streets was demolished in 1967. By 1971, the Pennsylvania Railroad itself was defunct.

Jimmy Stewart was born in Indiana in 1908 in a house at Philadelphia and 10th Streets. The family soon moved to their home on Vinegar Hill, not far from his father's hardware store. Stewart's Oscar was proudly displayed in its window for many years.

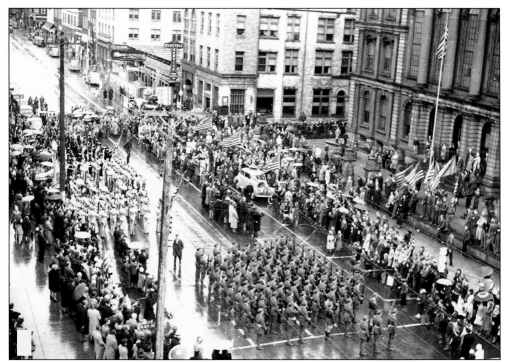

Wartime patriotism brought out large crowds in Indiana during World War II, even on cold and rainy days. Indiana County was a strong home-front supporter, contributing more than $17 million in war bonds and 14,000 men and women in military personnel. Coal was a crucial wartime material, and the county produced 10 million tons to aid the war effort in 1944.

Indiana High School students organized scrap drives to aid in the war effort, gathering collections like that seen here in 1943. They made enough money from their labors that the school was able to purchase a new organ.

During the war years, everyone in Indiana pulled together. The 1943 yearbook of the Indiana State Teachers' College (later Indiana University of Pennsylvania) showed the school's patriotism with this bold display of the 48-star flag waving proudly on its cover.

The 1943 OAK

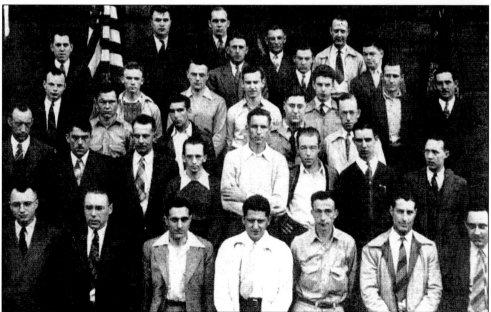

Pictured on May 29, 1943, is a typical group of World War II draftees in Indiana. They include Wilmer E. Roser, Clair T. White, John A. Brickell, Arthur W. McCurdy, James W. Miller, Adam S. Zbignewich Jr., James L. Foreman, Phillip D. McConnell, John L. Johnson, Richard J. Kennedy, Pete A. Micale Jr., Napoleon J. Patti, Lyle W. Kunkle, Howard E. Steffey, James F. Ober, James K. McElhoes, John C. McFarland, Paul B. Miller, Rudolph A. Steffish, Paul T. Bortz, Richard Sheehe, Theodore S. Elias, Richard E. Stear, Dennis W. Ray, Herbert R. Renz, William A. Simpson, David G. Buchanan, Robert D. Ruddock, Thad P. Work, Emery P. Faith, Albert S. Bernardo, Carl E. Dugan, Royden N. Tyger, and Roy J. Fishel.

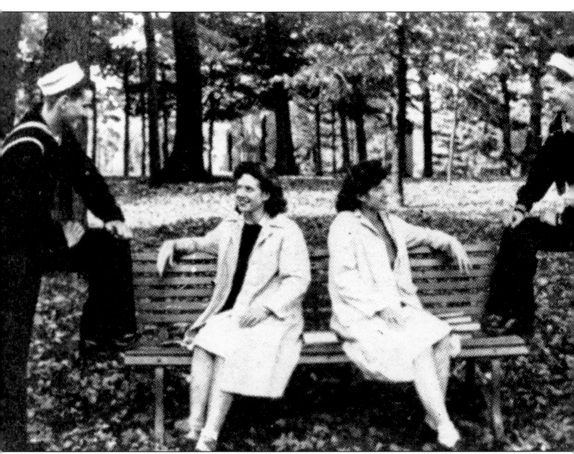

Soldiers and sailors were a frequent sight around town and on campus during and after World War II. Here are two handsome sailors courting a pair of lovely coeds. They are posed in the Oak Grove of the Indiana State Teachers' College (later Indiana University of Pennsylvania).

Six

REBUILDING
FOR THE FUTURE:
INDIANA SINCE 1946

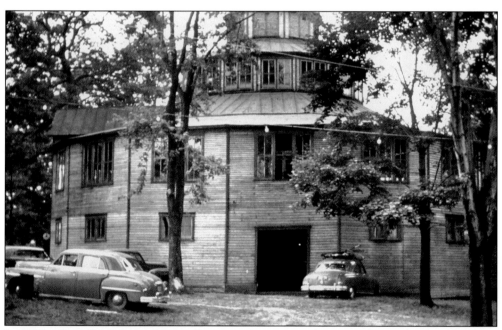

In 1892, when the Indiana County Fair moved to its new home on the south edge of town, a 16-sided building called the Round House was built as an "industrial building." The popular and intriguing structure was finally torn down in 1966 after falling into disrepair.

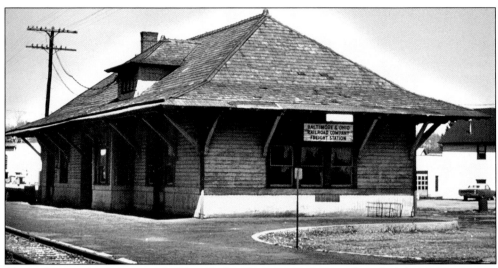

Shown here is the Baltimore & Ohio Railroad station at Papermill and Philadelphia Streets. The railroad, which once ran the "Hoodlebug" train, closed most of its stations in the 1960s. Indiana's station, one of the few not demolished, later became the Train Station Restaurant.

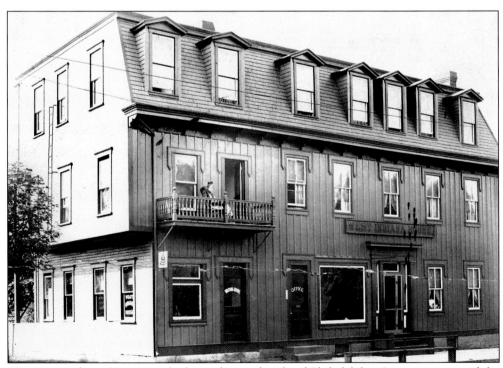

The West Indiana House was built on the south side of Philadelphia Street just west of the Episcopal church. It later became the Houk Hotel. In 1982, it was demolished to make way for newer structures.

In the late 1950s, Philadelphia Street was the hub of Indiana's activity. The Capitol Restaurant (later known as the Classroom Restaurant) and the Dairy Dell, seen here, were two of the more popular eateries.

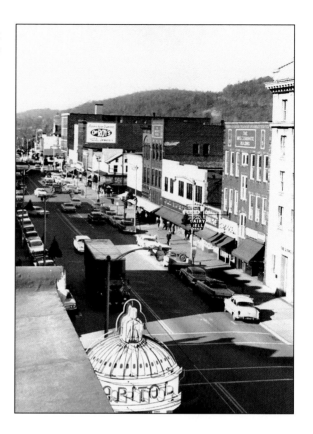

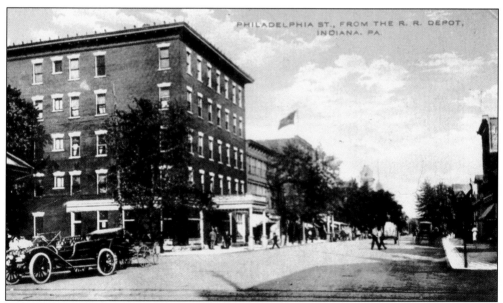

In the mid-1880s, the American Hotel had the most elegant dining room in the county. It was later to become the Moore Hotel, as seen here. Located next to the Pennsylvania Railroad Station, it was a popular stop. By the 1950s, most of Indiana's downtown hotels were on the decline, and the Moore finally closed after a 1966 fire.

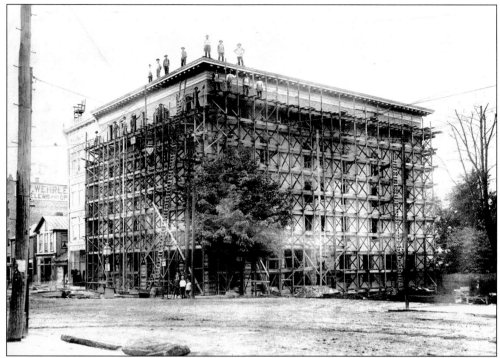

Work is being done here on the old Indiana Hotel. The downtown hotels had become less popular after World War II as motels on the outskirts were more common and accessible. The Indiana Hotel burned down in 1962, and Penn Furniture opened on the site soon after.

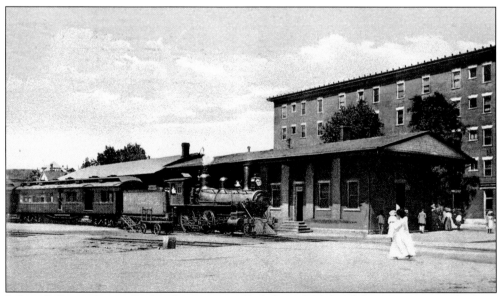

Indiana's Pennsylvania Railroad station, at Eighth and Philadelphia Streets, was built in 1855. In 1967, the station was sold to the Indiana County Redevelopment Authority, which demolished it in November of that year. Seen behind the train is the popular Moore Hotel.

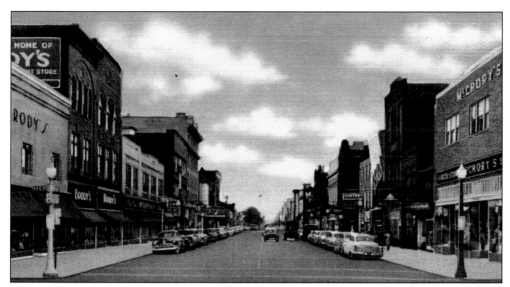

In the 1950s, Philadelphia Street was definitely the county's social and economic center, drawing large crowds and bumper-to-bumper parking during business hours. Angle parking was done away with in 1939. A year later, parking meters were installed.

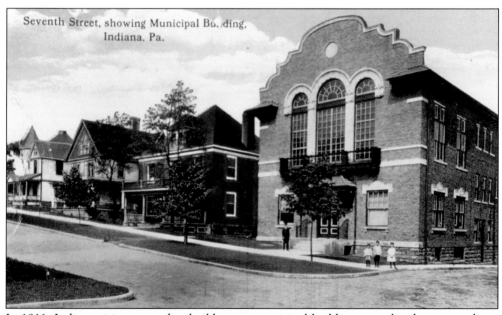

In 1911, Indiana citizens voted to build a new municipal building, completed two years later. When the fire whistle blew, the location of the fire was written on a chalkboard just inside the alley-side door (Nixon Avenue side), where firefighters and others could find out where the burning structure was. The building was remodeled in the mid-1980s.

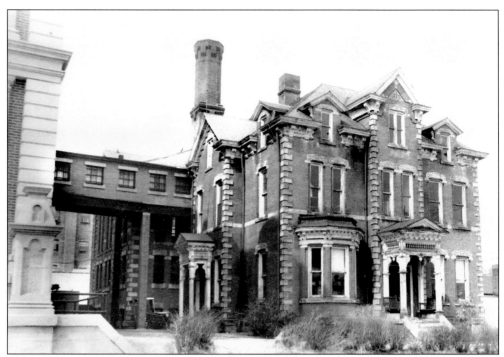

The prison warden's residence with the old jail behind it are attached to the Old Courthouse here by a "bridge of sighs," used for the secure transfer of prisoners between the buildings. Built in 1868 to remedy the problem of easy jailbreaks from the older stone jail, it was used until the newer facility was opened on Ninth Street in 1973.

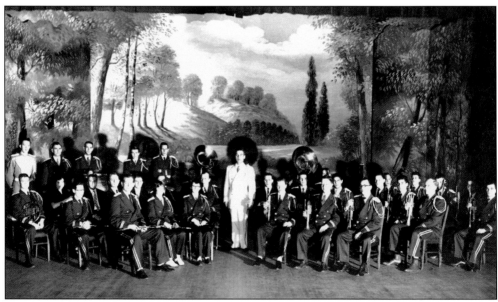

Construction on Fisher Auditorium on the Indiana University of Pennsylvania campus began in 1938 under the administration of Pres. Samuel Fausold. Its use by community groups such as the Indiana Municipal Band, shown here in 1954, illustrates the cooperative spirit between the town and campus encouraged by Gov. John S. Fisher, for whom the building was named.

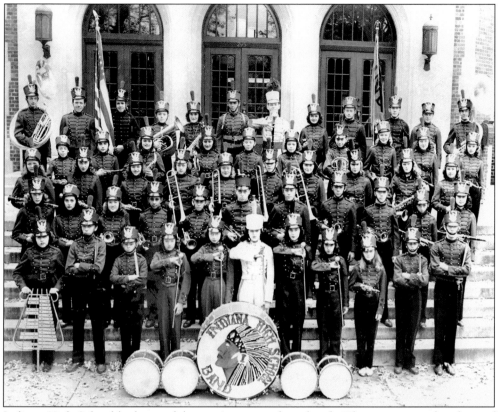

Indiana High School had one of the area's top marching bands. They are pictured in front of the high school c. 1940.

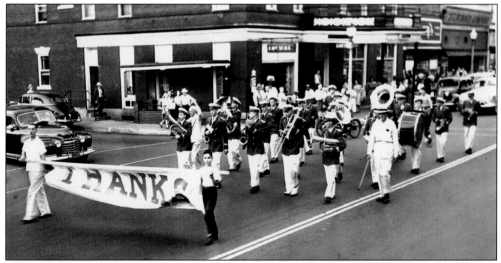

The Indiana Boy Scout Band was formed in 1920. Six years later, they supported their local candidate for governor by renaming themselves the John S. Fisher Band. Naming themselves after a political figure violated the Boy Scout charter, and in 1932, they were renamed the Indiana Municipal Band. They are pictured in 1948, by which time members of varying ages were included.

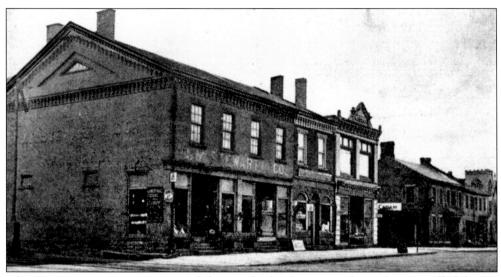

Alex Stewart, actor Jimmy Stewart's father, ran his hardware store from what was called the Big Warehouse, built in 1853, at the corner of Eighth and Philadelphia Streets. It was torn down in 1969 to make way for the new Savings & Trust Bank building.

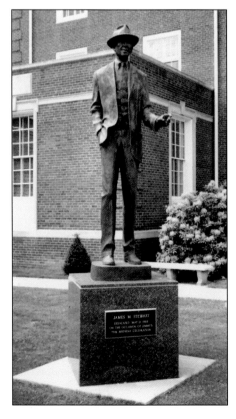

A statue to honor Indiana's beloved actor Jimmy Stewart was placed in front of the new courthouse and dedicated May 31, 1983, on Jimmy's birthday when he visited his hometown. The pose is one from his movie *Harvey*.

In 1975, Indiana native Jimmy Stewart returned to his hometown to celebrate Indiana University of Pennsylvania's 100th anniversary. He participated in a number of events on campus and was awarded an honorary doctoral degree as part of the university-wide commemoration of 100 years of education.

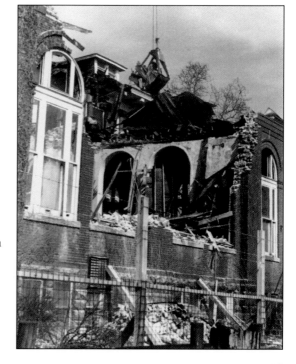

Leonard Hall on the Indiana State Teachers' College campus (later Indiana University of Pennsylvania) burned down in January 1951. The nighttime blaze in the landmark building was visible for miles around, and the fire was ranked the 10th worst in the nation that year. The structure was soon rebuilt.

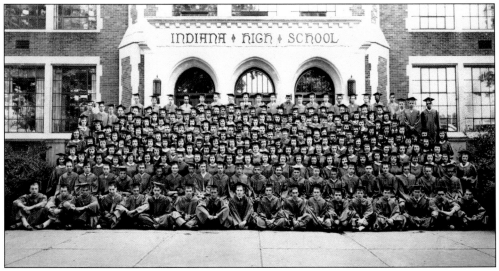

The members of the Indiana High School Class of 1948 are seen in front of their then 23-year-old high school. In 1963, this became the Indiana Junior High School with the construction of the new high school farther north on Fifth Street.

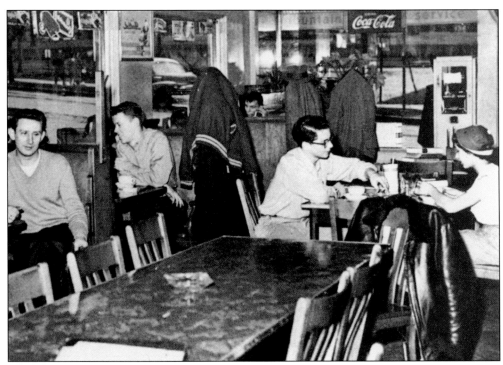

In the 1950s, diners and soda fountains sprang up near the Indiana State Teachers' College campus to support a growing student need for places to relax. Lefty Raymond's (later Pizza House) was one of the more popular venues for a soda, a snack, and often a smoke.

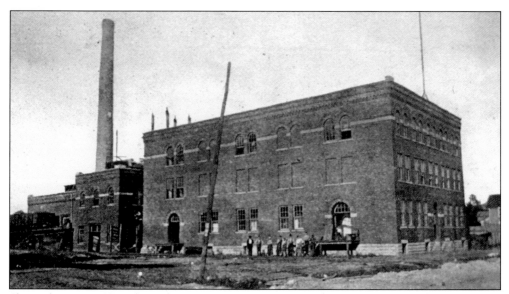

Shown here in 1907 is the Indiana Provision Company on Water Street, providers of both ice and electricity. The first town lights were hung across Philadelphia Street at Eighth Street. By 1905, a 150-foot smokestack was added. In 1912, the company was bought out as one of 19 regional companies merged into Pennsylvania Electric Company (PENELEC), growing to be the modern utility company we know today.

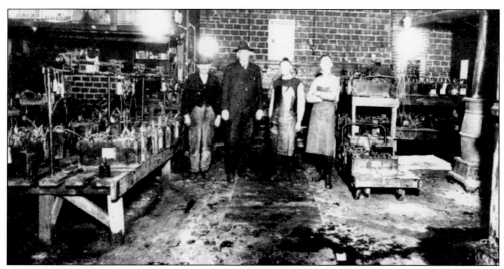

Seen here inside the Lightcap Electric Company in 1919 are, from left to right, R.L. McQuilkin, E.R. Lightcap, Foster Hill Sr., and Clyde McQuown. The company was a local institution for decades on Indiana's east side.

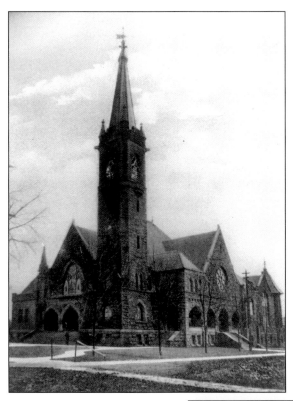

In 1906, Calvary Presbyterian Church completed what was considered the largest and most elegant church in the county. In 1966, the damaged steeple was removed after 60 years of struggling against Indiana's changeable weather.

In the mid-20th century, Indiana County began to truly celebrate the local Christmas tree industry, including the selection of a Queen Evergreen. The winner and two runners up are, from left to right, Sharon Cowan, Alida Pulsinelli, and Mary Lou Bair.

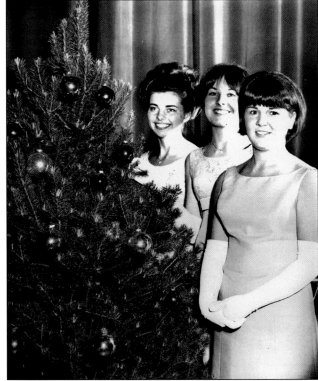

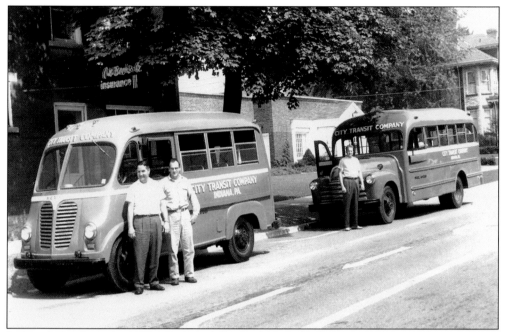

Indiana's popular street railway system fell out of use in the late 1920s and was completely shut down in 1933. The town was without public transportation, save taxis, until 1976 with one brief exception. From 1960 to 1961, the City Transit Company ran the buses seen here, serving Indiana borough and White Township.

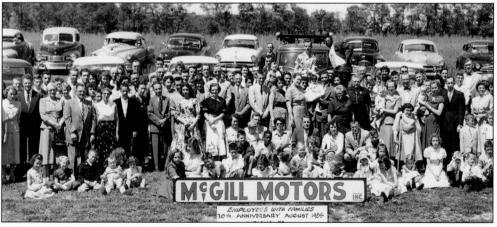

G.W. McGill purchased the Sutton Miller Ford agency and renamed it McGill Motors. His brother Lewis joined him at the dealership in 1945 after marrying Lois McCrory and working in the McCrory stores for several years. This photograph was taken 10 years after the brothers joined forces to run the business.

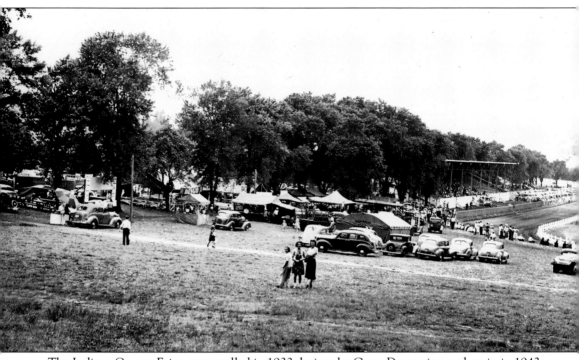

The Indiana County Fair was cancelled in 1932 during the Great Depression and again in 1943 during World War II. In other years, it was an immensely popular event, drawing visitors from the entire region.

Seven

TOWN AND GOWN: INDIANA'S EDUCATIONAL HERITAGE

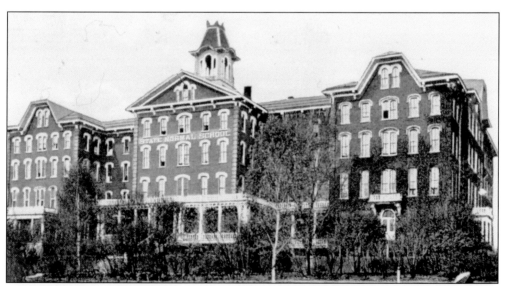

The Indiana State Normal School, with its main building of John Sutton Hall (shown here), was founded in 1875. It became Indiana State Teachers' College in 1927. Later, in 1959, it became Indiana State College. Gaining a nationwide reputation, it became Indiana University of Pennsylvania in 1965.

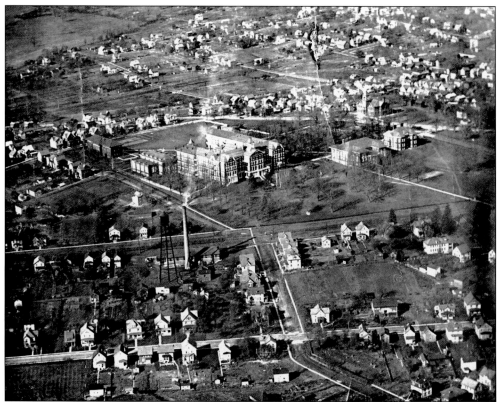

This 1919 aerial photograph shows the Indiana University of Pennsylvania (then Indiana State Normal School) campus shortly after the North Annex of Sutton Hall was added to provide more dormitory space. Note the power plant and recently built Leonard Hall, Thomas Sutton Hall, and rebuilt Clark Hall.

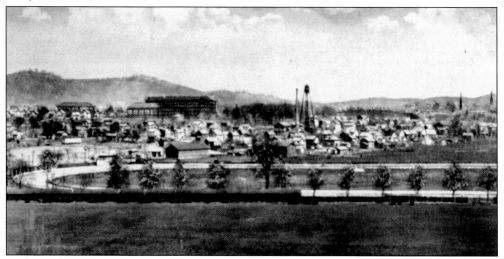

In the early 1900s, this view of Indiana was taken from the newly built Indiana Hospital. It shows the recently opened track at the fairgrounds as well as the growing Indiana State Normal School campus. Easily identified are Sutton Hall (the large building at left) and the campus power plant (smokestack and water tower).

The Indiana State Normal School was officially opened on May 17, 1875, under the administration of Dr. Edmund E. Fairfield. By the start of the first term, 225 students were enrolled. The curriculum included elementary, scientific, and classical courses.

FIRST CATALOGUE

OF THE

OFFICERS & STUDENTS

OF THE

State Normal School

OF THE

NINTH DISTRICT,

INDIANA, PENNSYLVANIA.

1875.

SECOND EDITION

PHILADELPHIA:
W. F. GEDDES' SONS, STEAM POWER PRINTERS,
No. 724 CHESTNUT STREET.
1875.

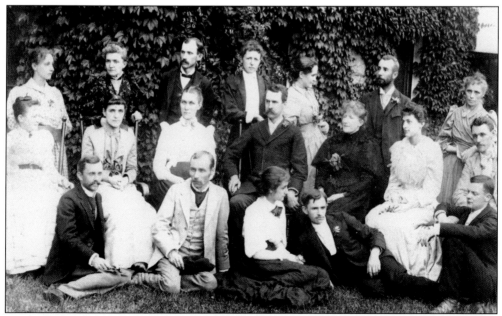

The Indiana State Normal School faculty seen here in 1893 was substantially smaller than today. Freshman courses taught by this group included chemistry, physics, grammar, literature, mathematics, teaching, elocution, reading, penmanship, drawing, geography, and history.

Jane Leonard, first geography and history teacher at the Indiana State Normal School was preceptress in Sutton Hall for more than 46 years. Although she was described as "prim and spinsterish," she was a staunch supporter of women's rights and was popular among the normal-school community. Leonard Hall was named in her honor.

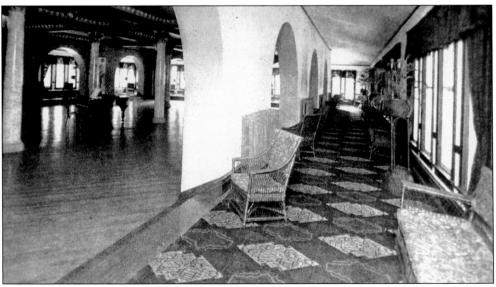

This 1915 photograph shows the newly built North Annex, added to John Sutton Hall at the Indiana State Normal School. Housing 64 women, it also included the lovely ambulatory, seen here, around three of its sides. The annex was torn down in 1979 to make way for the new Stapleton Library, but some of its ornamental windows and chandeliers were incorporated into John Sutton Hall.

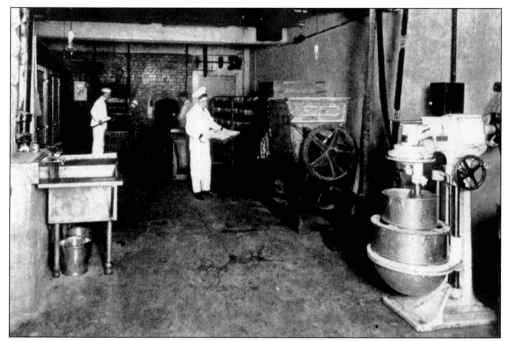

Providing for the needs of an ever-growing student body was a full-time chore for Indiana State Normal School staff. Laundry, cooking, and cleaning provided an unending cycle of work, lessened only during vacation times, when many students traveled home.

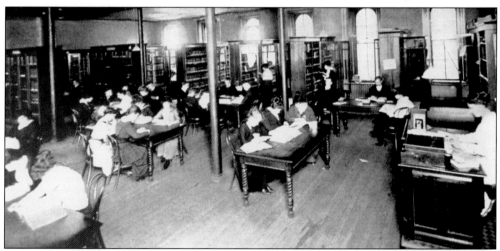

The Indiana State Normal School had an impressive library for the school's size. Twenty years after its opening, the library held nearly 3,000 volumes. By the time this photograph was taken c. 1915, the collection had grown to include more books, 98 journals, and nearly 100 newspapers, including a number of Indiana County daily and weekly publications.

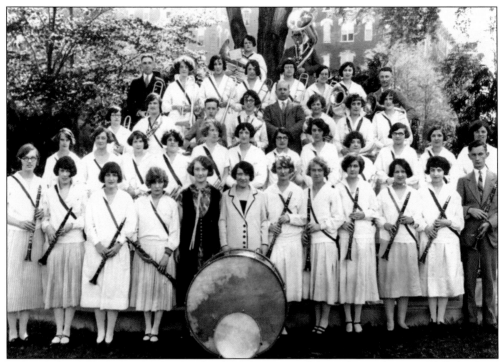

In 1925, the Indiana State Normal School band poses on the east lawn of Sutton Hall. In those days, most of the band was composed of female students.

State Normal School
Indiana Pennsylvania

Indiana State Normal School students have always exhibited strong school spirit. They often had pennants, flags, beanies, and other school-related decorations adorning the walls of their dormitory rooms. In those early days, rooms were not as individualized as they are today, and strict regulations limited what items students could bring with them to school.

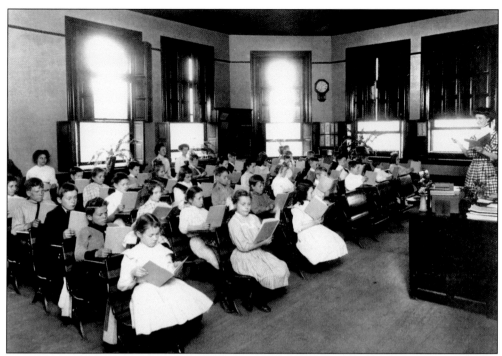

The opening of the conservatory in Thomas Sutton Hall in 1906 was a good choice and a complete success. Hamlin E. Cogswell was the director, and his daughter Edna and wife, Dorothy, were excellent musicians who taught classes such as this one in the conservatory.

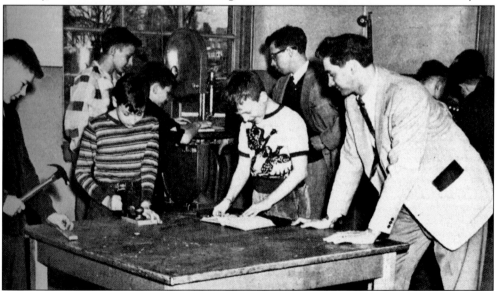

The Model Elementary School was mandated by state law to educate at least 100 local children, providing Indiana State Normal School students with the opportunity to practice teaching. Standard public school subjects were taught, primarily by senior students. Tuition in the 1880s ranged from $3 to $5 per year. By the 1950s, as seen here, the curriculum had changed substantially. The school (later called the University School) was a highly valued element of the campus and town partnership until budget cuts forced its closure in 2002.

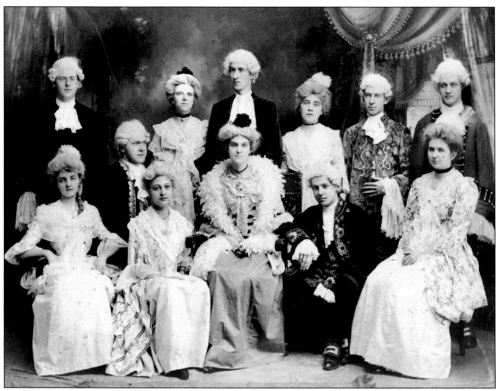

A popular event at the Indiana State Normal School was the George Washington Ball, a special activity for graduating classes. Seen here is the elegantly turned-out Class of 1907.

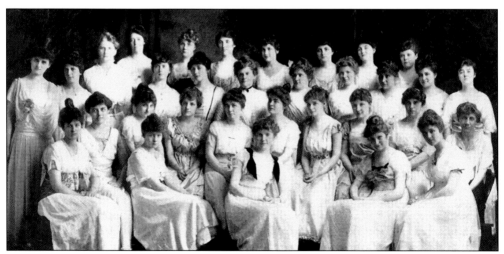

In the early years at the Indiana State Normal School, sororities were highly popular. In those days, faculty sponsors often lived in the houses with the students and took a very active, almost parental, role. Posing in 1915 are the members of Alpha Kappa Phi.

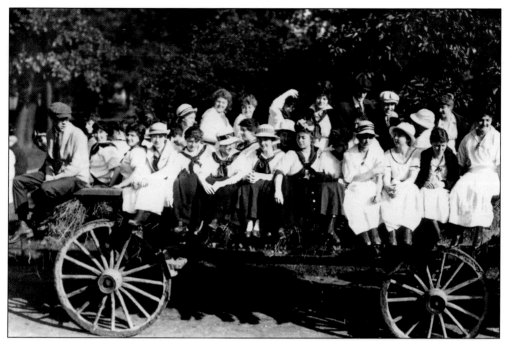

The hayride was one of the earliest and most popular of the school-sponsored recreational activities for Indiana State Normal School students. Other treats included sleigh rides and field trips.

The sleigh ride was as popular as the hayride was. Classes, student organizations, and groups of friends often planned their own outings to places like Two Lick Creek, Duman's Dam, and other nearby parks.

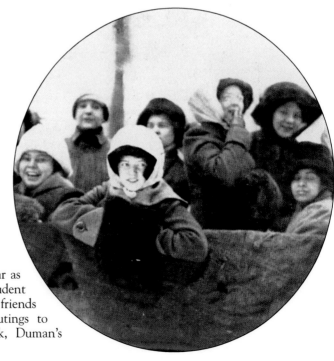

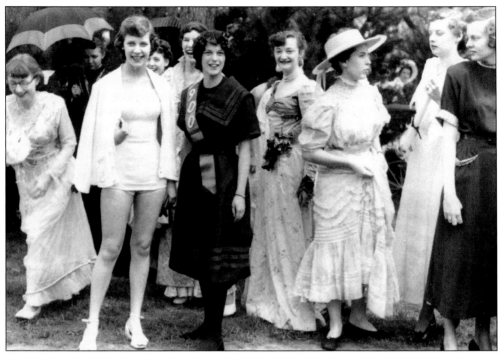

As final exams ended and commencement approached at the normal school, a variety of celebrations and traditions developed. This costume party is likely to have been one such event, allowing the stressed seniors an opportunity for fun and relaxation.

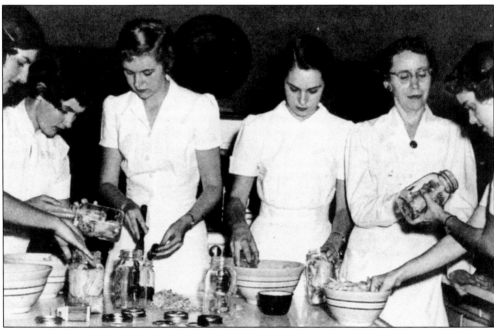

During the 1930s and 1940s, home economics classes like the one seen here taught young women useful skills like canning and preserving. The difficulties of obtaining some foods during the Great Depression and World War II made such skills essential for feeding families.

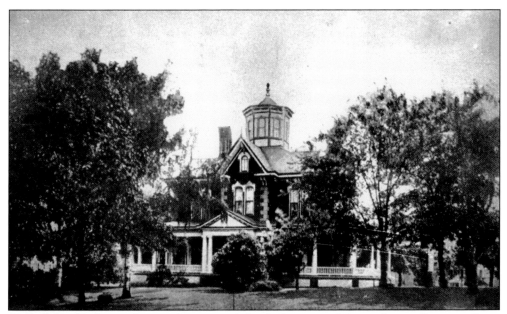

Breezedale, the former home of James and Sarah Sutton and Pennsylvania Supreme Court Justice John P. Elkin, was purchased by Indiana State Teachers' College in 1947. Stately and elegant, the building fell into minor disrepair and underwent a substantial restoration in the 1980s, coming to house Indiana University of Pennsylvania's Honors College.

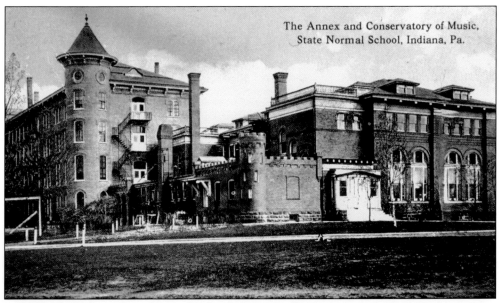

In 1892, the Indiana State Normal School chose to offer a separate vocal music department. By 1906, several rooms in Thomas Sutton Hall were designated a conservatory of music while others contained a laundry, kitchen, and other facilities for the rapidly growing school.

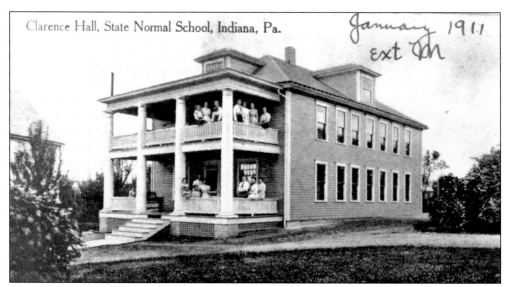

Clarence Hall, located by the corner of the railroad tracks (now Pratt Drive) and Locust Street, was a girls' dormitory at the Indiana State Normal School, rented from Clarence Smith in 1910. Rooms were available for $1,200 per year.

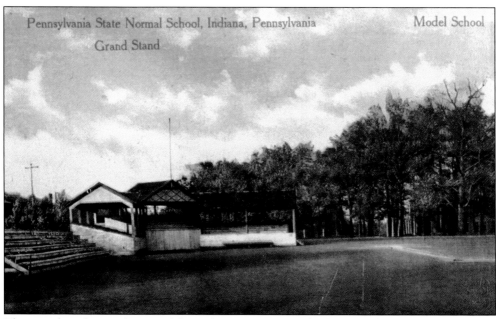

This grandstand was a feature of the Indiana State Normal School in its early days. In 1926, a new gymnasium, Waller Hall, was built on its site. Its primary feature was an indoor pool, 20 feet by 60 feet. The pool served campus until Zink Hall opened in 1976.

The east entrance to Sutton Hall is the one frequently used by the school's president and his family, who have always had apartments available in the main building. The entrance overlooks the east lawn, where Flagstone Theatre was later added.

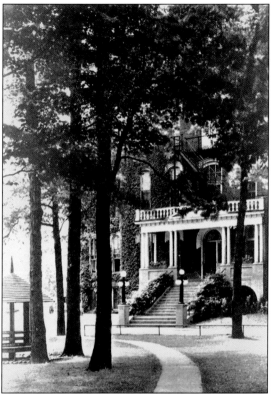

As the Indiana State Normal School became the Indiana State Teachers' College and student enrollment grew, so did the number and variety of items students brought to feel more at home in their dormitory rooms. More relaxed campus regulations by the time this photograph was taken allowed students to bring record players and radios among other items.

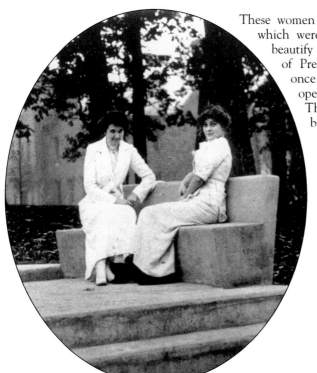

These women are posing on the Greek Steps, which were one of the many additions to beautify campus under the administration of Pres. James E. Ament. There was once a rose arbor just beyond the steps, opening onto the Oak Grove. The Thaddeus Stevens School is just barely visible in the background.

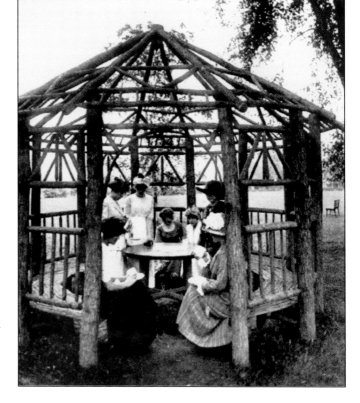

This log gazebo was a temporary but popular addition to campus. Many normal-school students took advantage of a rare sunny spring day to have lunch or tea in the gazebo while enjoying the out-of-doors.

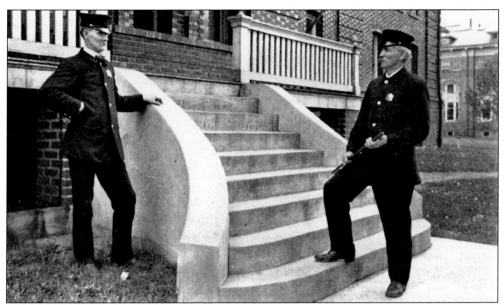

In its early days, the Indiana State Normal School accepted students as young as 14, and many students even older had rarely been away from home. For these students, normal-school faculty and staff were more like surrogate parents than we would expect today. The presence of officers on campus helped parents to feel better about sending their sons and daughters away to school.

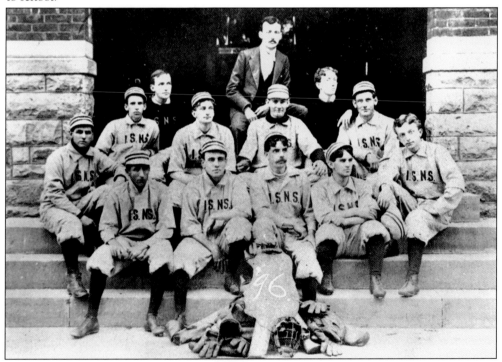

Organized sports emerged as a major aspect of Indiana State Normal School activities in the 1890s. Athletes were given free tuition as well as room and board. In addition to training players, coaches often played for the teams along with their student players.

The Indiana State Normal School's early emphasis on athletics produced many successful teams, including the 1917 football team, which won the national championship. Indiana's reputation attracted many talented athletes, such as Art Rooney, later the owner of the Pittsburgh Steelers.

Female students found that while some stretching and general calisthenics were required of them, it was not until the school was well established that they were fully involved in the athletic efforts of Indiana State Teachers' College. In the 1940s and 1950s, these students practice their archery skills.

The College Lodge is a 104-acre property acquired by the Indiana State Teachers' College on the west edge of town. With its ponds, woods, and hills, it has remained a popular destination in both summer and winter for outdoor and indoor activities. These students are hiking up the hill to enjoy a run down the ski slope. They may return to the lodge to curl up by the large fireplace with a cup of cocoa.

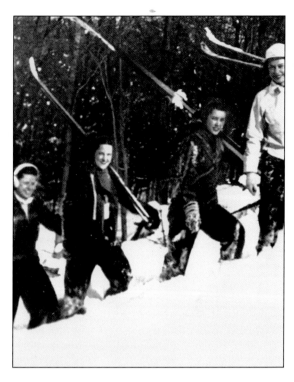

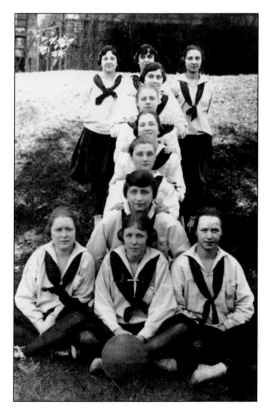

Student pride in the Indiana State Normal School has featured prominently since the school opened in 1875. These young women of the basketball team in the early 1900s pose on a campus hillside in the shape of an I, demonstrating their school spirit.

As part of freshman initiation customs, upperclassmen demanded subservience from incoming students for a two-week period. Here, two young men have dropped to their knees at the request of an older student.

Subject to the whims of upperclassmen, Indiana State Teachers' College freshmen submitted to a number of humorous but harmless pranks. Here, an unlucky guy is paddled while his more fortunate classmates look on.

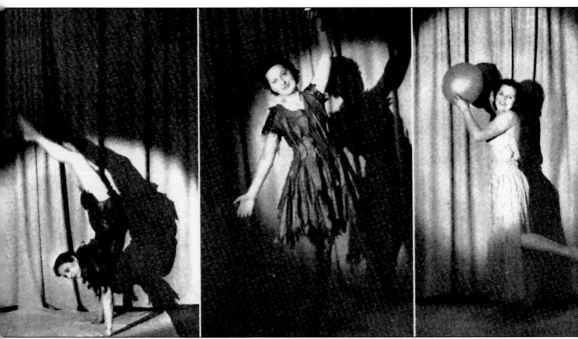

These students are shown in 1936 during the annual Swingout celebration. Sororities performed "laughter skits" as part of the festivities. This was an opportunity for breaking some of the stricter rules of campus behavior. The skits ranged from the elegant to the goofy to pure slapstick.

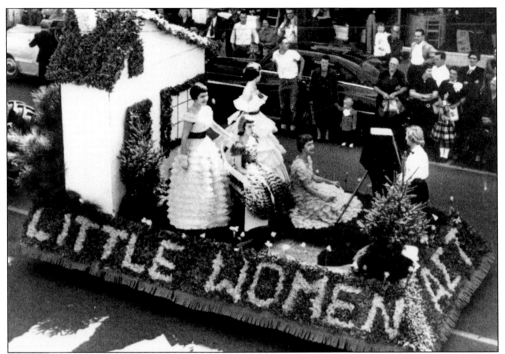

Homecoming parades have been a sign that autumn has arrived for decades of Indiana's permanent and student residents. Fraternities and sororities have been the major creators of parade floats like the one seen here.

Travel to and from the Indiana State Normal School was a more involved process in the early 20th century than it is today. Before many students had their own cars, most made longer trips by train. The students seen here are returning en masse after Christmas break in 1915. Special trains would arrive at the beginning and end of each term to collect or drop off hundreds of students. The tracks ran along the south side of campus where Pratt Drive now exists.

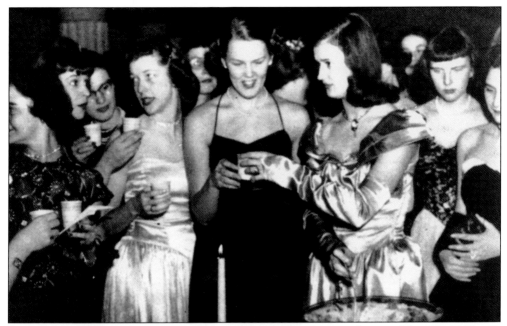

Fraternities and sororities have also had a number of their own traditions. After World War II, these groups grew in size and changed from primarily literary societies to social groups. These women are taking advantage of an opportunity to show off their formal gowns.

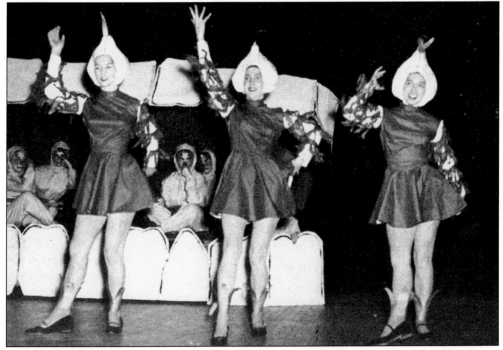

Not all sorority affairs were quite so elegant. Here, in 1934, the girls of Sigma Sigma Sigma perform a skit imitating onions. Such skits were performed by most of the Greek organizations on campus, providing many an entertaining evening during the Swingout celebration. Fraternity and sorority membership was very high in the 1950s.

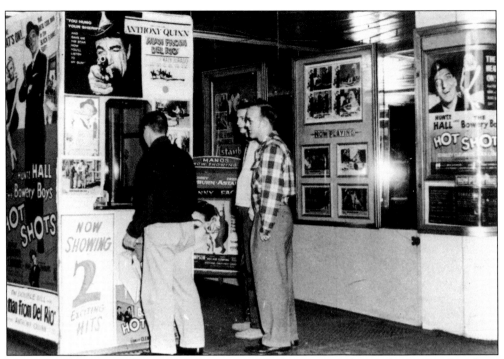

This 1956 photograph shows the booming Manos Theatre in Indiana's downtown. Residents and students old and young found themselves going to take in a show on a regular basis. Double features, such as *Hot Shots* and *The Man from Del Rio*, were a bargain.

Shown here is the graduating class of the Indiana State Normal School for 1925. Behind this pyramid of students is John Sutton Hall, built in 1875, the original building and center of campus life in those years.

In the early years at the Indiana State Normal School, all of the students lived on campus. Female students were treated to sitting rooms and parlors in John Sutton Hall, which also served as their dormitory. Such elegance as that seen here seems extravagant for a dormitory today but was quite common in the colleges of the day. Much attention was paid to details, and dormitory life was quite formal and regimented.

The experience of life in a dormitory is a common one shared among generations of Indiana's students. Although the facilities and certainly the fashions have changed, the activities, pleasures, and pains of dormitory life differ only in their details over the years.

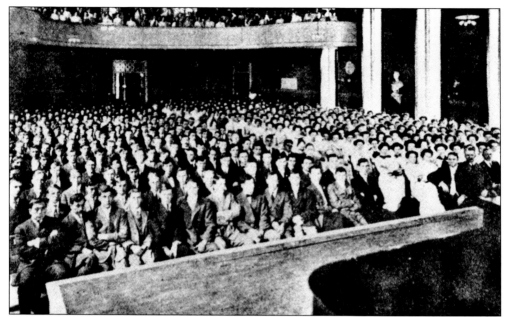

Religious activities were a mandatory aspect of attendance at the Indiana State Normal School. The school catalog of 1876 proclaimed, "All students are expected to attend public service on Sabbath day; either at some place in town, or in the Normal School Chapel when services are held there." Seen here is one such chapel service, held in John Sutton Hall.

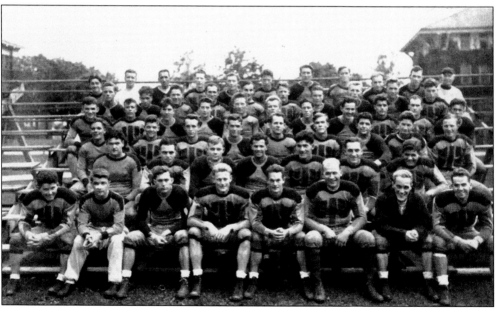

Here is the 1936 Indiana State Teachers' College football squad, coached by George P. Miller, for whom the campus stadium was later named. Under his coaching, the team had a 5-3 season in 1936, with especially high honors racked up against Edinboro, Clarion, California, and Shippensburg. Top players that year included Marshall Woodring, Harold Fulton, Franklin George, Kenneth Greene, Frederick Tomb, Charles Beretta, Harold Errigo, Max Dick, George Hay, Ralph Kelley, Donald King, Earl Kohler, Edward McDowell, and Edward Vokes.

Increasing enrollment at Indiana State Teachers' College placed greater demands on the institution's facilities. The original campus power plant, built in 1891 under principal Dr. Z.X. Snyder, was rebuilt in 1913. Again, in 1927, it was remodeled to include three 391-horsepower coal-fired boilers. Part of the plant's machinery is seen here in 1936.

The close relationship between the university and surrounding communities has enabled the formation of a number of mutually beneficial partnerships. Local businessmen and contractors have frequently been called upon to perform work at various campus locations. In this view, workmen from Kunkle's Lumber in Homer City install a new floor in the recreation hall.

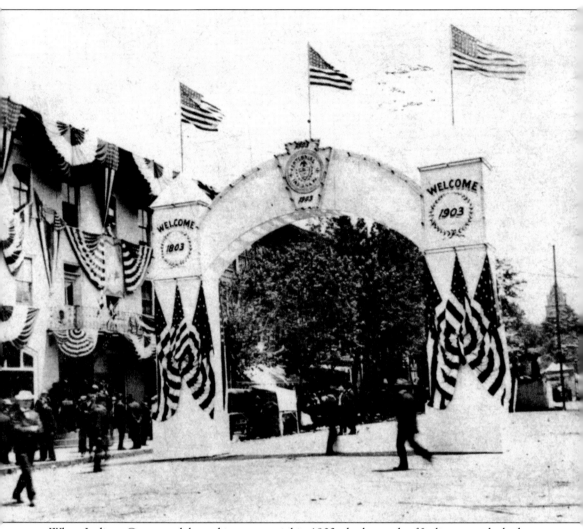

When Indiana County celebrated its centennial in 1903, the borough of Indiana was decked out in bunting and flags from sidewalk to rooftop. The archway seen here was built to commemorate Indiana's passage into a second century of existence. The ensuing 100 years have had their ups and downs, which we commemorate now as we approach the Indiana County bicentennial.